PARIS VERTICAL

PARIS VERTICAL

HORST HAMANN

teNeues

SOMMAIRE / CONTENTS

Martin Page est né le 7 février 1975 à Paris, où il réside actuellement. Il fait 1,80 m, aime boire du thé et prête peu d'attention à son apparence. Il lui arrive d'aller à la piscine. Il adore les journées pluvieuses et déteste le dimanche. Ce n'est plus un étudiant, bien qu'on ne puisse pas dire qu'il en ait jamais été vraiment un. Il vit à Paris, dans le quartier de Château Rouge. Ses romans sont traduits en 25 langues. On le considère comme le Woody Allen français.

Martin Page was born on February 7, 1975 in Paris, where he lives now. He is five feet, eleven inches tall, likes to drink tea, and does not watch his figure. Sometimes he goes to the swimming pool. He loves rainy days and hates Sundays. Without ever really having been one, he is no longer a student. He lives in Paris, at Chateau Rouge. His novels are translated in 25 languages. He is considered France's Woody Allen.

Martin Page wurde am 7. Februar 1975 in Paris geboren, wo er auch heute lebt. Er ist 1,80 m groß, trinkt gerne Tee und achtet nicht auf seine Figur. Manchmal geht er ins Schwimmbad. Er liebt Regentage und hasst Sonntage. Er ist kein Student mehr und war auch nie wirklich einer. Er lebt in Paris im Quartier Château Rouge. Seine Romane werden in 25 Sprachen übersetzt. Er wird als der Woody Allen Frankreichs angesehen.

Martin Page nació el 7 de febrero de 1975 en París, donde reside actualmente. Mide 1,80 m, le gusta tomar té, no tiene en cuenta su figura. Algunas veces va a la piscina. Le encantan los días de lluvia y odia los domingos. Ya no es un estudiante, aunque en realidad no lo fue nunca. Esta domiciliado en el barrio parisiense Chateau Rouge. Sus novelas han sido traducidas en 25 idiomas. Es considerado como el Woody Allen de Francia.

Martin Page è nato il 7 febbraio 1975 a Parigi, dove vive attualmente. È alto 1,80 m, gli piace bere il tè, e non presta attenzione alla sua immagine. Qualche volta va in piscina. Adora le giornate piovose e odia la domenica. Senza esserlo realmente mai stato, non è più uno studente. Vive a Parigi, al Chateau Rouge. I suoi romanzi sono stati tradotti in 25 lingue. È considerato il Woody Allen francese.

PARIS: UNE REALITE OFF-SHORE
MARTIN PAGE

Il y a très longtemps qu'on ne voit plus Paris. Paris est effacé par les cartes postales. Paris a disparu sous les ruines de la renommée. On y aime, on y boit, on y mange. Paris n'est qu'un parfum, l'aspirine de l'amour, le cocktail pétillant de la passion.

Il arrive un moment où une ville parvient à maturité, elle est remplie et ne peut plus grandir. La ville est faite. Alors il ne reste plus qu'une chose à construire: l'architecture de ce que nous voyons. Rues, palais, églises et parcs attendent que le doux marteau de nos yeux les façonne. Pour rendre Paris visible, il faut se débarrasser de l'habitude de nos yeux, casser nos orbites, trop ovales, trop horizontales, briser notre pauvre point de vue.

Je n'ai jamais vu la Tour Eiffel, je ne crois pas aux Champs-Elysées, et surtout je n'ai jamais pensé, pas un seul instant, que Paris se trouvait en France. Non, Paris est une réalité off-shore.

A un ami qui me demandait pourquoi j'avais choisi cette ville, je répondis que j'habitais Paris pour vivre à l'étranger. Tous les pays sont là, à disposition. Dans ses cinémas, librairies et restaurants, on trouve la planète entière. Les étrangers en sont les seuls habitants indispensables car ils insufflent une dose salvatrice d'incommunicabilité. Quand on commence à comprendre quelqu'un, on est inévitablement déçu. Le malentendu est le mur porteur des relations sociales. Le malentendu a fait de Paris une grande ville de rencontres et de discussions, la capitale de l'amour.

Les touristes sont la matière première de Paris. Ils vivent dans des autocars ou sous des casquettes et des lunettes de soleil. Paris produit des touristes par millions et les exporte dans tous les pays du monde où ils deviennent des Hollandais, des Japonais, des Russes. Il faut visiter les touristes, ce sont les plus intéressants monuments parisiens. C'est incroyable ce que l'on trouve dans un touriste. Fabriqués avec des dizaines de pays, de religions et de langues, leur richesse semble inépuisable.

Paris, à l'origine, est une île, une île sur un fleuve. Aujourd'hui, elle est une île perdue au milieu d'un océan de terre. De prestigieux voyageurs se réfugièrent sur ses bords. Il ne faut pas venir à Paris, mais y échouer, à la limite y accoster. Mais, attention, il y a beaucoup de pièges à éviter. Par exemple, il serait regrettable de trouver la ville immédiatement belle. Cette beauté aveuglante dilate les pupilles et élimine les paysages minuscules.

Après tout, Paris n'est pas si aimable. Il y a trop de voitures, trop de pigeons et l'amabilité n'est pas la plus grande vertu des Parisiens. Selon moi, c'est un système de défense. Paris a appris à se faire détester et à s'enlaidir. Et cela est heureux, car, à une époque, notre capitale devenait trop désirée. Trop d'amants voulaient l'étreindre, elle risquait de succomber sous les baisers. Paris pourrait être une ville très agréable, mais elle ne se laisse pas saisir si facilement, il faut du courage et de l'imagination pour l'aimer.

L'aurore est le moment idéal pour découvrir Paris. Laissez tomber les excursions culturelles et les jardins; si vous voulez visiter et comprendre Paris, dès le premier rayon du soleil, sortez dans la rue ou installez une chaise sur votre balcon. La ville est déserte et calme. Il y a alors quelque chose de la Vallée des Rois. On comprend que cette ville est une ville de Pharaons. Cela ne dure pas: sitôt que les Parisiens se réveillent, Paris disparaît.

Les cimetières de Paris sont ses plus beaux musées. Auparavant les gens mouraient uniquement pour que l'on sculpte de belles tombes et qu'on les plante au Père Lachaise. Mais on ne meurt plus à Paris. On n'a pas le temps. Il y a toujours autre chose à faire, une expo à voir, un film, une promenade, un repas à préparer pour des amis, une conversation à continuer. Pour mourir, on prend le train, l'avion ou la voiture et on va à la campagne ou à l'étranger, enfin dans tous ces endroits de vacances. On quitte Paris pour mourir, pour laisser à son coeur le loisir d'arrêter de battre.

Je ne sais pas s'il fait bon vivre à Paris. Sans doute pas. Mais je crois qu'il n'y a pas de meilleur endroit sur Terre où ne pas bien vivre.

Paris est un guet-apens et un mensonge dont les racines nourrissent les histoires. Ce n'est pas la plus belle ville du monde, ni la plus romantique, ni la plus intelligente. Mais elle possède le charme qui nous permet de la voir ainsi. Paris est un rêve que l'on veut faire. Nous voulons y croire, et cette croyance que nous déposons au bord de la Seine comme une offrande donne son pouvoir à la ville et la nourrit. Voilà pourquoi les livres et les rêves que les artistes ont fait de cette ville sont les plus grandes réalisations de son architecture.

PARIS: A REALITY UNTO ITSELF
MARTIN PAGE

Paris has been hidden from view for a very long time now. Postcards have erased it. It has vanished beneath the ruins of its fame. People there continue to love, to drink, to eat. Paris is nothing but a scent, a painkiller for love, the sparkling cocktail of passion.

There comes a time when a city reaches maturity, when it is full and cannot grow any further. The city is complete. Only one thing is left to construct: the architecture of what we see. Streets, palaces, churches, and parks wait to take shape under our gaze as a sculpture takes shape beneath the hammer and chisel. To make Paris visible, we must get rid of our old habits of seeing things, transcend the physical constraints imposed by our eyes, and form a new point of view.

I have never seen the Eiffel Tower, I do not believe in the Champs-Elysées, and above all, I have never thought, not for a single second, that Paris is located in France. No, Paris is a reality unto itself.

When a friend asked me why I had chosen this city in particular, I answered that I lived in Paris in order to live abroad. All the countries of the world are represented there. In its movie theaters, bookstores, and restaurants, you can find the whole planet. Foreigners are the only truly indispensable residents of Paris, because they breathe into the city a healing dose of the incommunicable. Understanding another person is inevitably followed by disappointment. Misunderstandings, on the other hand, are the linchpin of social interaction. Misunderstandings have made Paris into a grand city of social encounters and discussions, the capital of love.

Tourists are the raw materials of Paris. They live in cars, under hats, behind sunglasses. Paris produces tourists by the million and exports them to every country in the world, where they then become Dutchmen, Japanese, Russians. The tourists of Paris are not to be missed; they are the most interesting monuments in the city. It is incredible what one may find in so doing. Manufactured out of dozens of countries, religions, and languages, their rich variety seems to be inexhaustible.

Paris was originally an island, an island in a river. Today, it is an island lost amid an ocean of land. Prestigious voyagers have found refuge on its shores. One does not simply come to Paris, but one runs aground there, or, if necessary, docks there temporarily. But be careful – there are many pitfalls to avoid. For example, it would be regrettable if one immediately found the city beautiful. That kind of dazzling beauty dilates our pupils and blinds us to the small picture.

After all, Paris is not that loveable. There are too many cars, too many pigeons, and amiability is hardly Parisians' greatest virtue. In my opinion, this is a defense mechanism. Paris has learned how to make others dislike it and find it ugly. And this is a good thing, because at one point, our capital was much too well liked. Too many lovers tried to embrace it, and it ran the very real risk of suffocating in their grasp. Paris could be a very pleasant city indeed, but it does not let itself be caught so easily; one needs courage and imagination in order to love it.

Dawn is the perfect time to discover Paris. Forget about cultural excursions and visiting the gardens – if you want to visit and understand Paris, go out onto the street or settle into a chair on your balcony when the first rays of dawn break. The city is deserted and calm. It evokes the Valley of the Kings. One understands that this city is a city of the Pharaohs. It doesn't last: as soon as the Parisians awake, Paris disappears.

The cemeteries of Paris are its most beautiful museums. In an earlier age, people would die solely so that beautiful tombs would be sculpted for them and put up at Père Lachaise. But nobody dies in Paris anymore. No one has the time. There is always something to do, an exhibition to see, a film, a promenade, a meal to prepare for friends, a conversation to continue. To die, one takes a plane, train, or automobile to the countryside or out of the country – in short, to any vacation destination. One leaves Paris in order to die, to give one's heart the leisure time to relax and stop beating.

I don't know if it does one good to live in Paris. Undoubtedly not. But I do believe that there is no better place on Earth to not live well. Paris is an ambush and a lie; its roots give rise to stories. It is not the most beautiful city in the world, nor the most romantic, nor yet the most intelligent. But it does possess the charm that permits us to view it as such. Paris is a dream one wants to dream. We want to believe in it, and this belief that we leave along the banks of the Seine like an offering nourishes Paris and gives it power. And that is why the books and the dreams artists have created about this city are the greatest manifestations of its architecture.

PARIS: IRGENDWO IM MEER
MARTIN PAGE

Schon seit langem kann man Paris nicht mehr sehen. Die Postkarten haben das Bild der Stadt verblassen lassen. Paris liegt verschüttet unter den Ruinen ihres Rufes. Paris ist nur ein Duft, eine Liebesdroge, ein prickelnder Cocktail der Leidenschaft.

Es kommt ein Moment, an dem eine Stadt ihren Höhepunkt erreicht hat, an dem sie ausgereift ist und nicht mehr weiter wachsen kann. Das Einzige, was es noch zu entwerfen und erschaffen gilt, ist ihr Bild, das wir mit unseren Augen gestalten und formen wie Bildhauer. Um Paris sehen zu können, müssen wir unsere Augen aus ihrem Dämmerschlaf erwecken und uns einer ganz neuen Sichtweise öffnen.

Ich war nie auf dem Eiffelturm, ich glaube nicht an die Bedeutung der Champs-Elysées und vor allem habe ich, nicht einmal für einen kurzen Augenblick gedacht, dass Paris in Frankreich liegt. Nein, Paris liegt irgendwo draußen im Meer.

Als mich ein Freund fragte, warum ich in Paris gelandet bin, antwortete ich, dass ich in dieser Stadt wohne, um im Ausland zu leben. Man findet den gesamten Planeten. Die Ausländer sind die wirklich unentbehrlichen Einwohner von Paris, da sie Verständigungsschwierigkeiten und Missverständnisse verursachen. Denn wenn man beginnt, jemanden zu verstehen, ist man zwangsläufig enttäuscht. Das Missverständnis ist der wichtigste Stützpfeiler sozialer Beziehungen. Diese heilsame Dosis an Missverständnissen hat Paris zur großen Stadt der Begegnungen gemacht, zur Hauptstadt der Liebe.

Die Touristen sind die wichtigsten Bestandteile von Paris. Man findet sie in den Reisebussen oder unter Schirmmützen und Sonnenbrillen. Paris erschafft Millionen von Touristen und exportiert sie in alle Länder der Welt, wo sie dann Holländer, Japaner oder Russen werden. Eigentlich müsste man in Paris die Touristen besichtigen. Es ist unglaublich, wie verschieden sie sind. Sie kommen aus zahlreichen Ländern, haben die unterschiedlichsten Religionen und sprechen die verschiedensten Sprachen. Sie scheinen in ihrer Vielfalt unerschöpflich zu sein.

Ursprünglich war Paris eine Insel in einem Fluss. Heute liegt die Stadt verloren inmitten eines Meeres aus Land. Viele haben sich an ihre Ufer geflüchtet. Man kommt nicht einfach nach Paris, man strandet dort. Aber man darf dieser grellen Schönheit nicht sofort verfallen. Sie weitet die Pupillen und trübt den Blick für die Details.

Alles in allem ist Paris nicht sehr liebenswert. Es gibt zu viele Autos und zu viele Tauben. Freundlichkeit ist nicht gerade die größte Tugend der Pariser. Meiner Meinung nach ist das eher eine Form der Verteidigung. Paris hat gelernt, sich unbeliebt und unattraktiv zu machen. Und das ist durchaus erfreulich, denn es gab einmal eine Zeit, da war unsere Hauptstadt sogar zu beliebt. Zu viele Liebende wollten sie umarmen und die Stadt drohte in dieser Umklammerung zu ersticken. Paris könnte eine liebenswerte Stadt sein, doch sie ist schwer zu verstehen, man benötigt Mut und Phantasie, um sie zu lieben.

Wenn Sie Paris sehen und verstehen möchten, gehen Sie beim ersten morgendlichen Sonnenstrahl durch die Straßen oder setzen Sie sich auf den Balkon. Die Stadt ist verlassen und ruhig. Wie das Tal der Könige. Man merkt, dass diese Stadt eine Stadt der Pharaonen ist. Doch dieser Eindruck ist nicht von Dauer. Sobald die Pariser erwachen, verschwindet dieses Bild von Paris.

Die Friedhöfe von Paris sind die schönsten Museen. Früher starben die Menschen dort nur, damit man ihnen schöne Grabsteine schuf. Aber heute stirbt man nicht mehr in Paris. Dafür ist keine Zeit. Es gibt immer etwas zu tun, man muss eine Ausstellung besuchen, einen Film sehen oder eine Unterhaltung fortsetzen. Um zu sterben, nimmt man den Zug, das Flugzeug oder das Auto und begibt sich aufs Land. Man verlässt Paris, um zu sterben, um es seinem Herzen zu gestatten, mit dem Schlagen aufzuhören.

Ich weiß nicht, ob es gut ist, in Paris zu leben. Wahrscheinlich nicht. Aber ich glaube, es gibt auf der Welt keinen besseren Ort, um nicht gut zu leben.

Paris ist eine Lüge, die unsere Träume und Phantasien nährt und unseren Blick verschleiert. Es ist weder die schönste Stadt der Welt, noch die romantischste. Doch sie besitzt einen Charme, der sie uns so sehen lässt. Paris möchte man träumen. Wir wollen an ihren Zauber glauben. Eben dieser Glaube, den wir am Ufer der Seine wie ein Almosen ablegen, verleiht der Stadt Kraft und Energie. Deshalb sind die von Künstlern geschaffenen Bücher und Träume über Paris die wahren Monumente der Stadt.

PARÍS: UNA REALIDAD OFF-SHORE
MARTIN PAGE

Hace mucho tiempo que hemos dejado de ver París. La metrópoli se ha desvanecido por las postales, desapareciendo bajo las ruinas de su renombre. Es un lugar donde se ama, se bebe y se come. París es tan sólo un perfume, una aspirina del amor, un cóctel burbujeante de la pasión.

Llega un momento cuando una ciudad está madura, está llena y ya no crece. Es decir, que ha sido concluida. Entonces sólo nos queda una cosa: construir la arquitectura que estamos viendo. Calles, palacios, iglesias y parques forjados por el suave martillo de nuestros ojos. Para realmente ver París debemos deshacernos de las habitudes de nuestros ojos, salir de nuestra órbita demasiado ovalada, demasiado horizontal, acabar con nuestro miserable punto de vista.

Jamás he visto la Torre Eiffel, no he atravesado los Campos Elíseos y ni una sola vez he pensado que París se encuentra en Francia. No, París es una realidad "off-shore".

A un amigo, que me preguntó por qué había elegido esta ciudad, le contesté que yo vivía en París para vivir en el extranjero. Allí se encuentran todos los países a tu alcance. En sus cines, bibliotecas y restaurantes uno encontrará un planeta entero. Los extranjeros son los únicos habitantes indispensables porque confieren este aire salvador de incomunicabilidad. Cuando se comienza a entender a alguien, ya se produce la desilusión. El malentendido es el muro que soporta las relaciones sociales. Gracias al malentendido, París es una metrópoli de reuniones y discusiones, la capital del amor.

Los turistas son la materia prima de París. Viven en autocares, debajo de gorras o detrás de gafas para el sol. París produce millones de turistas y los exporta a todos los países del mundo donde se convierten en holandeses, japoneses o rusos. Conviene visitar a los turistas, los monumentos más interesantes de París. Es increíble lo que puede encontrarse en un turista. Fabricados de docenas de países, religiones e idiomas, su riqueza es inagotable.

París, en primer lugar, es una isla, una isla en un río. Hoy en día, es una isla perdida en el centro de un océano de tierra. Unos viajeros prestigiosos han buscado refugio en ésta. A París no se llega, sino que se encalla y se atraca en esta isla. Pero, cuidado, hay muchas trampas que uno debe evitar. Por ejemplo, sería fatal pensar inmediatamente que la ciudad es muy bonita. Esta belleza cegadora dilata las pupilas y elimina los paisajes minúsculos.

Al fin y al cabo, París no es muy amable. Hay demasiados coches, demasiadas palomas y, efectivamente, la amabilidad no es de por sí una de las grandes virtudes de los parisienses. Pienso que se trata de un sistema de defensa. París ha aprendido a ser detestable ya que había una época en la que nuestra capital era excesivamente querida. Demasiados amantes la querían abrazar, amenazando con ahogarla bajo sus besos. París podría ser una ciudad muy agradable. Pero no es fácil de conquistar, hay que ser valiente y tener imaginación para amarla.

La aurora es el momento ideal para descubrir París. Dejemos las excursiones culturales y los parques. Si desea visitar y entender París, desde el primer rayo de sol, salga a la calle o siéntese en su balcón. La ciudad está desierta y reina la calma. Emana cierto aire al Valle de los Reyes. Ahora se entiende que es una ciudad de los Faraones. Pero ello no durará: En cuanto se despiertan los parisienses, París desaparece.

Los cementerios de París son sus museos más bellos. Antaño, la gente se moría sólo para terminar con un sepulcro hermoso en el cementerio Père Lachaise. Sin embargo, en París ya no se muere. No hay tiempo para ello. Siempre hay otra cosa que hacer: visitar una exposición, ver una película, dar un paseo, preparar una comida para los amigos, continuar una conversación, etc. Para morir hay que tomar el tren, el avión o bien el coche e irse al campo o al extranjero, bueno a los lugares habituales de vacaciones. Se abandona París para morir, para ofrecer a su corazón la libertad de dejar de latir.

No sé si es bueno vivir en París. Pienso que no. Sin embargo, creo que no haya un lugar mejor en el mundo para vivir a gusto. París es una emboscada y una ficción en la que las raíces alimentan las historias. No es la ciudad más bella del mundo, ni tampoco la más romántica o la más inteligente. Sin embargo, posee un encanto que nos permite considerarla como tal. París es un sueño que uno desea disfrutar. La queremos y creemos en ella. Y esta convicción que depositamos a orillas de la Sena como una ofrenda, confiere fuerza a la ciudad y la alimenta. Por ello, los libros y las ilusiones de los artistas acerca de esta ciudad son las obras más grandes de su arquitectura.

PARIGI: UNA REALTÀ OFF-SHORE
MARTIN PAGE

È da molto che non si vede più Parigi. La città è ormai stata sostituita dalle cartoline. È scomparsa sotto le rovine della fama. Ci si ama, si beve, si mangia. Parigi non è che un profumo, l'aspirina dell'amore, il cocktail frizzante della passione.

Giunge un momento in cui una città è matura e completa e non può più crescere. La città è ormai finita. A quel punto resta una sola cosa da realizzare: l'architettura di ciò che vediamo. Strade, palazzi, chiese e parchi attendono solo che il delicato martello dei nostri occhi li modelli. Per vedere Parigi, bisogna liberare i nostri occhi dall'abitudine, cambiare le nostre orbite, troppo ovali, troppo orizzontali, rompere il nostro insignificante punto di vista.

Io non ho mai visto la Torre Eiffel, non credo agli Champs-Elysées, e soprattutto non ho mai pensato, nemmeno per un istante, che Parigi si trovasse in Francia. Parigi è una realtà off-shore.

A un amico che mi chiedeva perché avevo scelto questa città, risposi che vivevo a Parigi per vivere all'estero. Qui si trovano tutti i paesi, a disposizione. Nei suoi cinema, librerie e ristoranti, si incontra l'intero pianeta. Gli stranieri sono gli unici abitanti necessari a infondere una dose liberatrice di incomunicabilità. Fino a quando si inizia a capire che qualcuno è rimasto inevitabilmente deluso. L'equivoco è il muro portante delle relazioni sociali. L'equivoco ha fatto di Parigi una grande città di incontri e discussioni, la capitale dell'amore.

I turisti sono il fulcro di Parigi. Vivono in pullman o sotto i berretti e gli occhiali da sole. Parigi produce milioni di turisti e li esporta in tutti i paesi del mondo dove diventano Olandesi, Giapponesi, Russi. Bisogna visitare i turisti, sono i monumenti più interessanti della città. È incredibile quello che si riesce a trovare in un turista. Composti da dozzine di paesi, religioni e lingue, hanno una ricchezza inesauribile.

Parigi, in origine, era un'isola, un'isola lungo un fiume. Oggi, è un'isola perduta in mezzo a un oceano di terra. Viaggiatori autorevoli approdano sulle sue rive. Non bisogna venire a Parigi, ma arenarsi, al massimo avvicinarsi. Ma, attenzione, ci sono molte trappole da evitare. Ad esempio, sarebbe antipatico trovare la città subito bella. Questa bellezza accecante dilata le pupille e nasconde i piccoli paesaggi.

Dopo tutto, Parigi non è così interessante. Ci sono troppe auto, troppi colombi e l'amabilità non è la più grande virtù dei parigini. Secondo me, si tratta di un meccanismo di difesa. Parigi ha imparato a farsi odiare e a imbruttirsi.
E questo è positivo, poiché, un tempo, la nostra capitale era diventata troppo ambita. Troppi amanti la desideravano, rischiavano di soccombere sotto i baci. Parigi potrebbe essere una città molto piacevole, ma non si lascia afferrare tanto facilmente, ci vuole coraggio e immaginazione per amarla.

L'alba è il momento ideale per scoprire Parigi. Lasciate perdere le escursioni culturali e i giardini, se volete visitare e capire Parigi, dal primo raggio di sole, uscite in strada o piazzate una sedia sul balcone. La città è deserta e tranquilla. È in questo momento che compare qualcosa della Valle dei Re. Si capisce che si tratta di una città di Faraoni. Ma non dura a lungo: non appena i parigini si risvegliano, Parigi scompare.

I cimiteri di Parigi sono i musei più affascinanti da visitare. Prima le persone morivano solamente perché si scolpissero delle belle tombe e per farsi tumulare al Père Lachaise. Ma ora non si muore più a Parigi. Non si ha il tempo. C'è sempre qualcosa da fare, una mostra da vedere, un film, una passeggiata, un pranzo da preparare per gli amici, una conversazione da continuare. Per morire, si prende il treno, l'aereo o la macchina e si va in campagna o all'estero, insomma in tutti questi luoghi di vacanze. Per morire si va via da Parigi, per lasciare al suo cuore il tempo di smettere di battere.

Non so se si vive bene a Parigi. Sicuramente no. Ma credo che non esista un posto migliore sulla Terra dove si viva bene.

Parigi è una trappola e una menzogna le cui radici alimentano la storia. Non è la città più bella del mondo, né la più romantica o la più intelligente. Ma ha in sé il fascino che ci permette di vederla in questo modo. Parigi è un sogno che si vuol realizzare. Vogliamo crederci, e questa convinzione che noi poniamo sulle rive della Senna come un'offerta dà il suo potere alla città e la nutre. Ecco perché i libri e i sogni che gli artisti hanno fatto su questa città sono le maggiori opere della sua architettura.

VERTICALES / VERTICALS

Paris est la plus belle manière de quitter New York.

Paris is the most beautiful way to leave New York.

Tilo Kaiser, Peintre

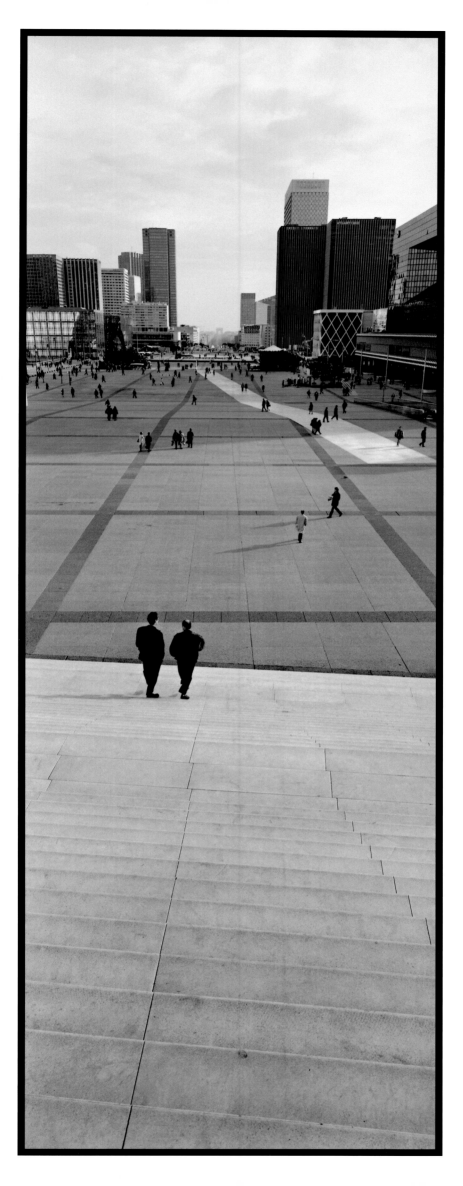

**L'Architecture est une tournure
d'esprit et non un métier.**

Architecture is not a profession,
it's a state of mind.

Le Corbusier, Architecte

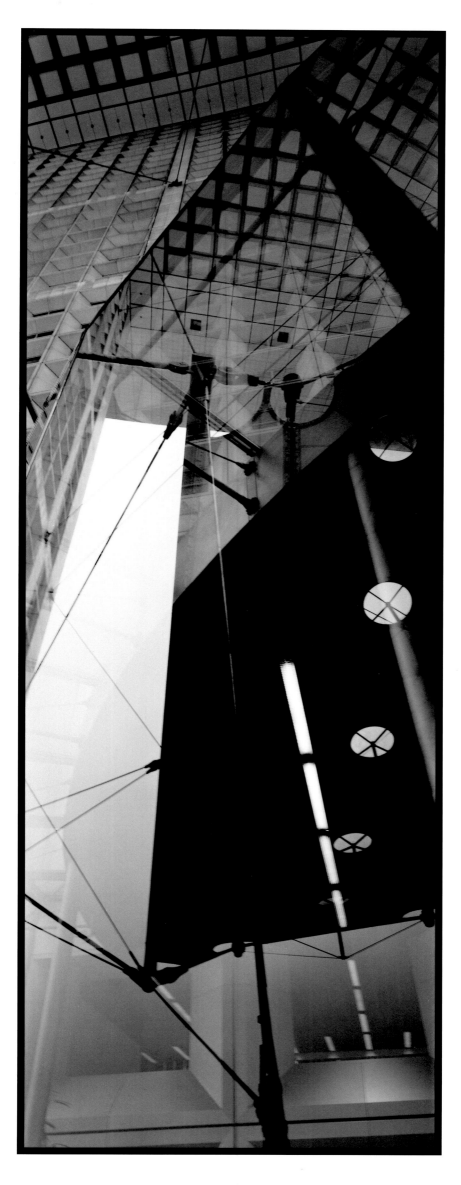

Je verrai Paris pour la
dernière fois le jour de ma mort.
La ville comme son souvenir
sont inépuisables.

The last time I see Paris
will be on the day I die.
The city was inexhaustible
and so its memory.

Elliot Paul, Ecrivain

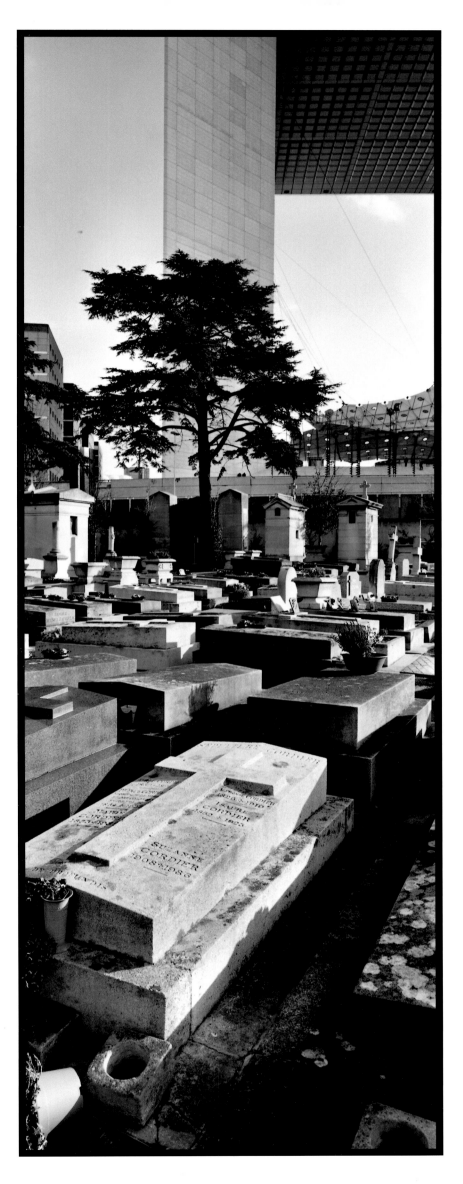

Paris gris, grise les étrangers.

Paris, gray and colorless,
exhilarates foreigners.

Hyun Soo Choi, Peintre

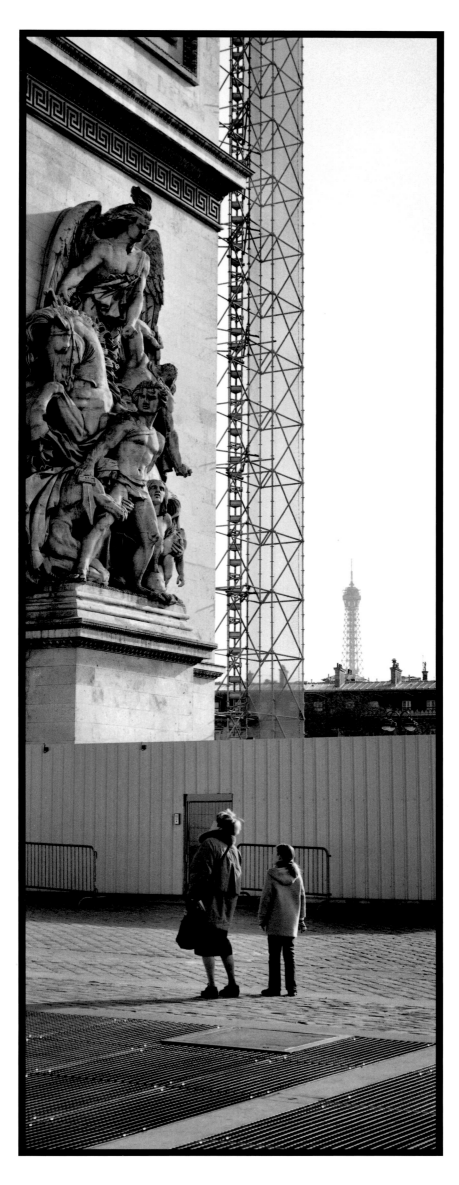

Paris la féminine et New York phallique, l'une centrée sur son flux, l'autre embrassée par son fleuve, se complètent et règnent sur les imaginaires les plus divers.

Paris the feminine and New York the phallic: the one focused on its state of flux, the other encircled by its river, complete one another and reign together over the most varied imaginations.

Véronique Nguyen, *Journaliste*

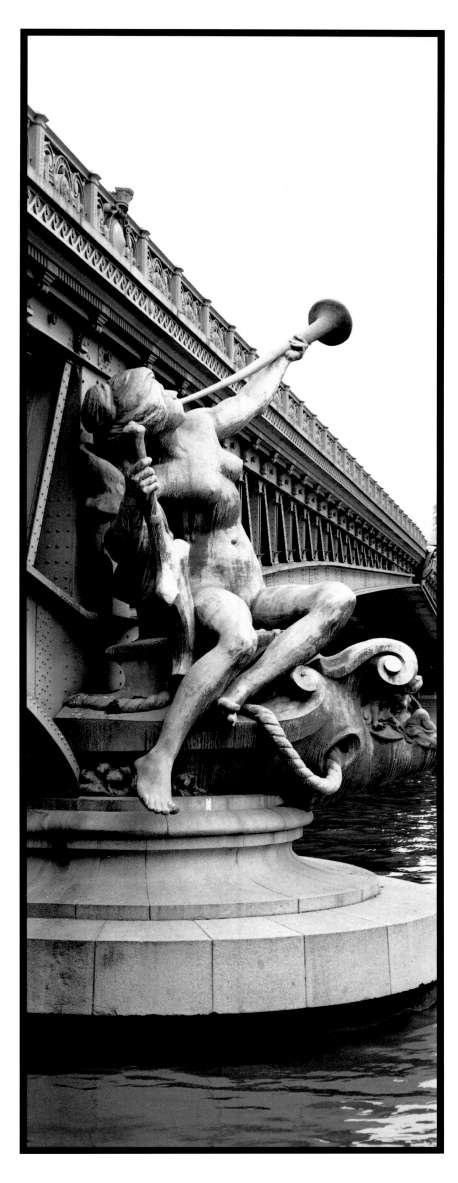

**Ajoutez deux lettres à Paris:
c'est le paradis.**

Just add three letters to Paris,
and you have paradise.

Jules Renard, Ecrivain / Humoriste

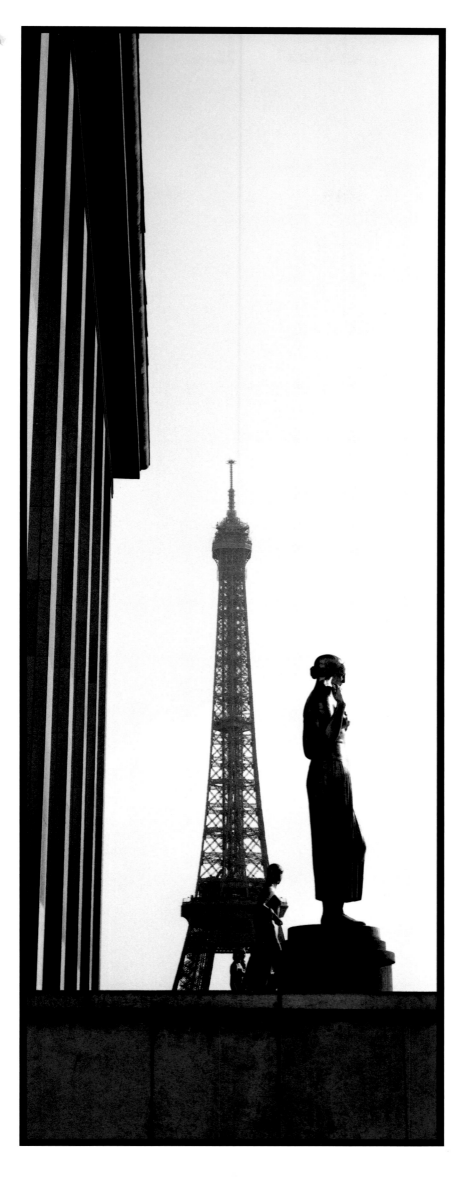

Ah, bien je prétends que
les courbes des quatre arêtes
du monument, telles que le
calcul les a fournies, donneront
une grande impression de force
et de beauté.

Well, I think the curves of the
four pillars of the monument,
as the calculations have provided
them, give it a great sense of
force and beauty.

Gustave Eiffel, Architecte

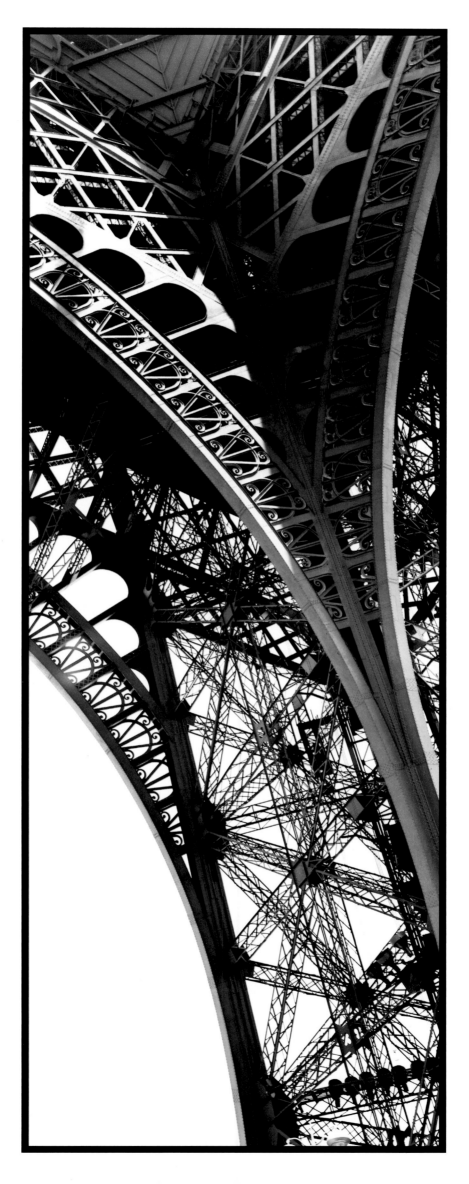

Une femme a besoin de six mois
de Paris pour connaître ce qui lui
est dû, et quel est son empire.

A woman needs six months in
Paris to know what is her due
and the extent of her empire.

Napoléon Bonaparte

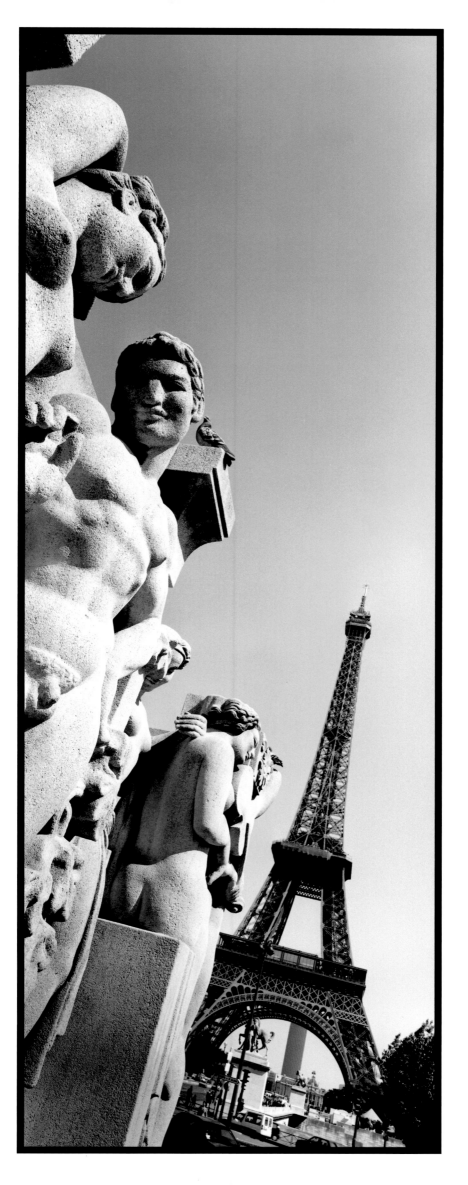

**L'air de Paris est si mauvais
que je le fais toujours bouillir
avant de respirer.**

The air is so bad in Paris that I
boil it before breathing it.

Erik Satie, Compositeur

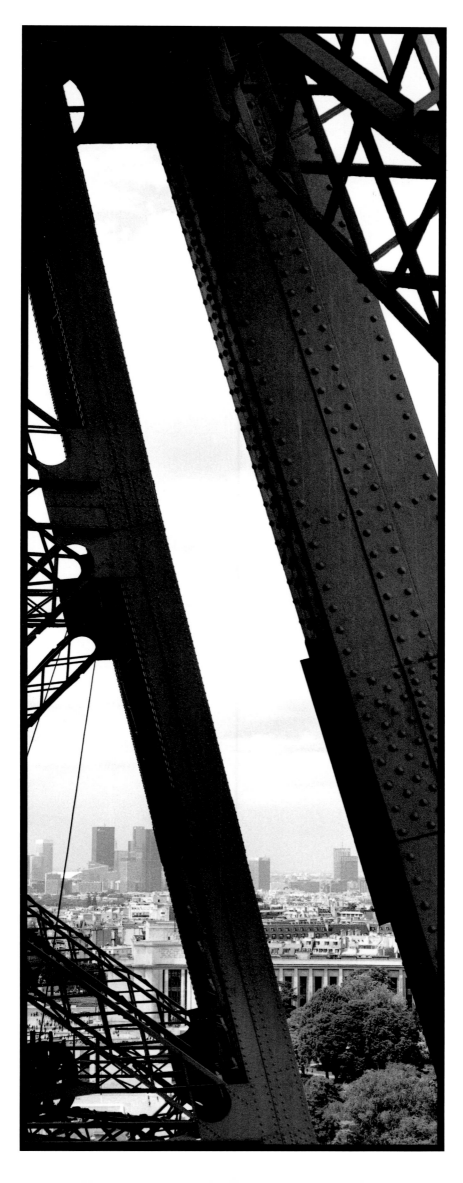

Quand Paris éternue, l'Europe s'enrhume.

When Paris sneezes,
Europe catches a cold.

Prince Metternich, Homme d'Etat Autrichien

**Avec une pomme,
je veux étonner Paris.**

With an apple,
I will astonish Paris.

Paul Cézanne, Peintre

Paris! Principe et fin!
Paris! Ombre et flambeau!
Je ne sais si c'est mal, tout cela;
mais c'est beau!
Mais c'est grand! Mais on sent
jusqu'au fond de son âme
qu'un monde tout nouveau se forge
à cette flamme.

Paris! The beginning and the end!
Paris! Shadow and blazing light!
I don't know if it is bad, all this;
but it is beautiful!
How grand it is!
One feels it all the way
to the depths of your soul,
that a whole new world
is being forged in this flame.

Alfred de Vigny, Poète

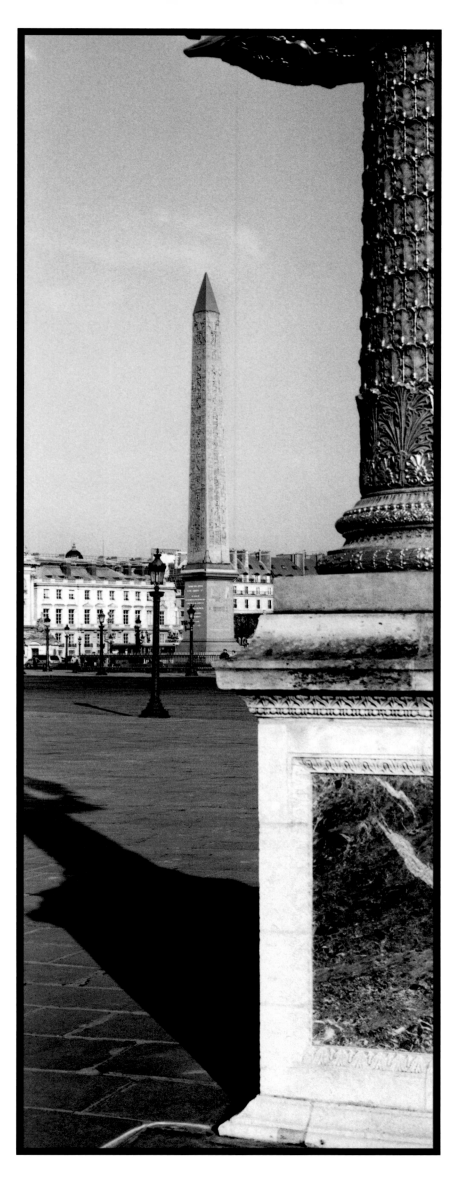

Ces Français, mon vieux, ils ont un mot différent pour tout.

Boy, those French — they have a different word for everything.

Steve Martin, Acteur / Comédien

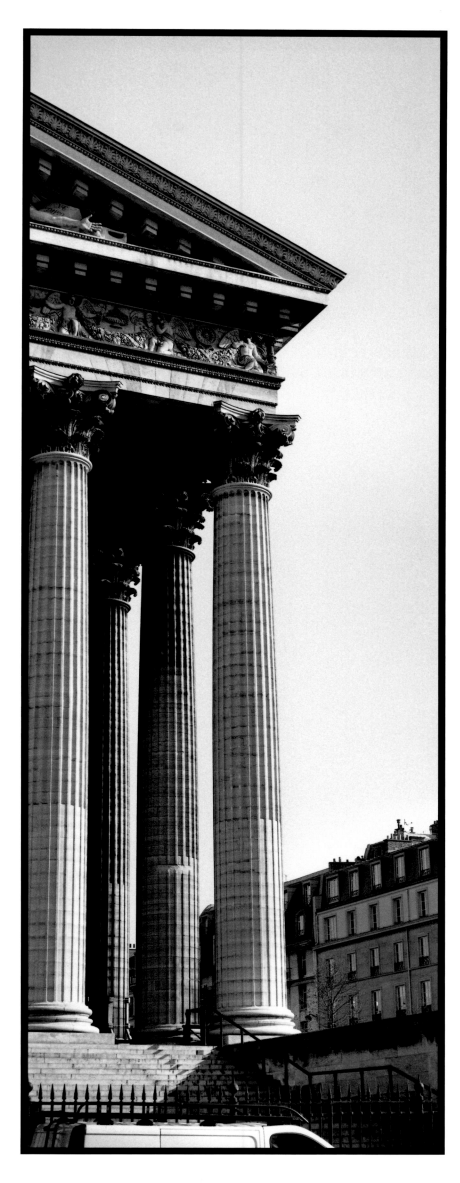

**Laisser conduire à Paris
sa voiture à sa femme,
c'est vouloir soit une autre
voiture, soit une autre femme.**

**If one lets one's wife drive in Paris,
one must want either a different
car or a different wife.**

Paul Guth, Ecrivain

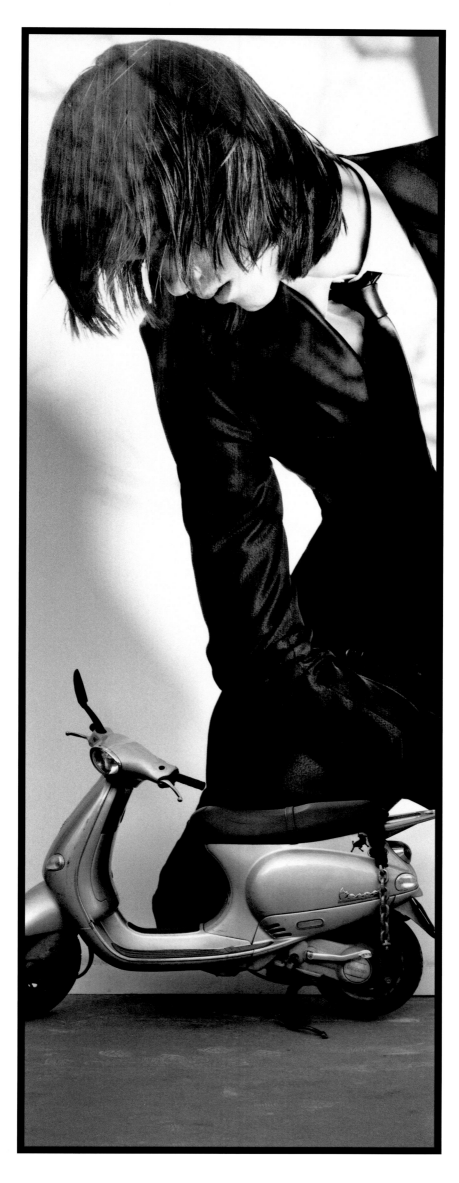

On peut aller partout en partant de Paris si l'on est sûr d'y revenir.

From Paris, you can go everywhere, as long as you're sure to come back.

Peter Lindbergh, Photographe

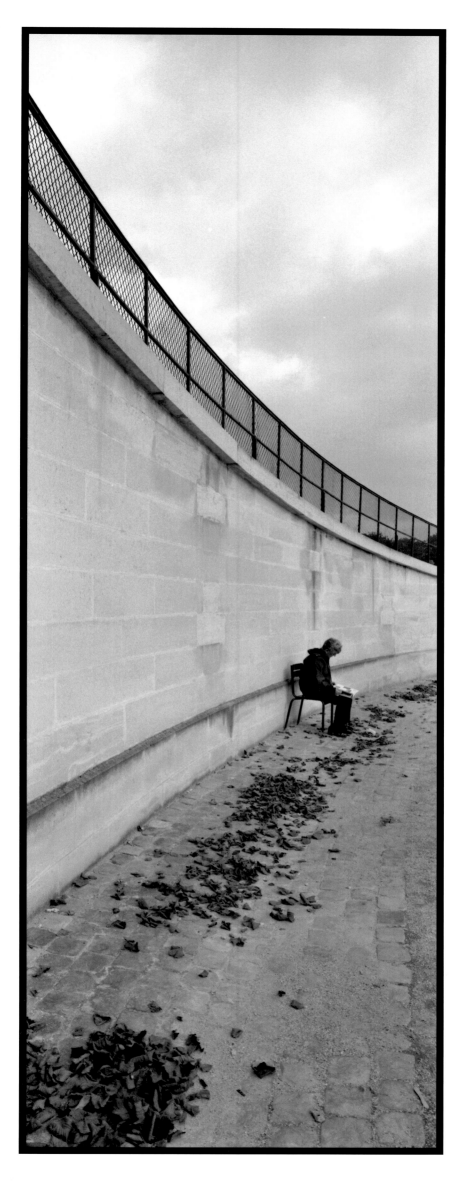

**Quelle est la différence
entre une vierge et Paris?
Paris sera toujours Paris.**

What's the difference between
Paris and a virgin?
Paris will always be Paris.

Aurélie Ben Barek, Artiste

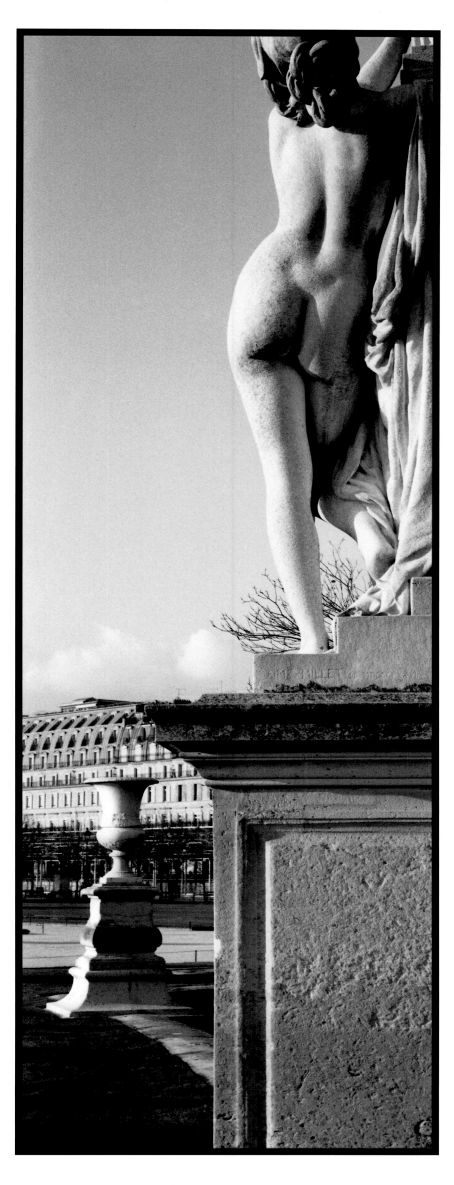

A Paris, la tentation revêt une
tout autre dimension.
Être capable de résister à sa
sensualité, c'est être déjà mort.

In Paris, temptation takes on
an entirely different dimension.
Those who can resist its
sensuality are bound to have
died in some sense.

Jaques Riboux, Chorégraphe

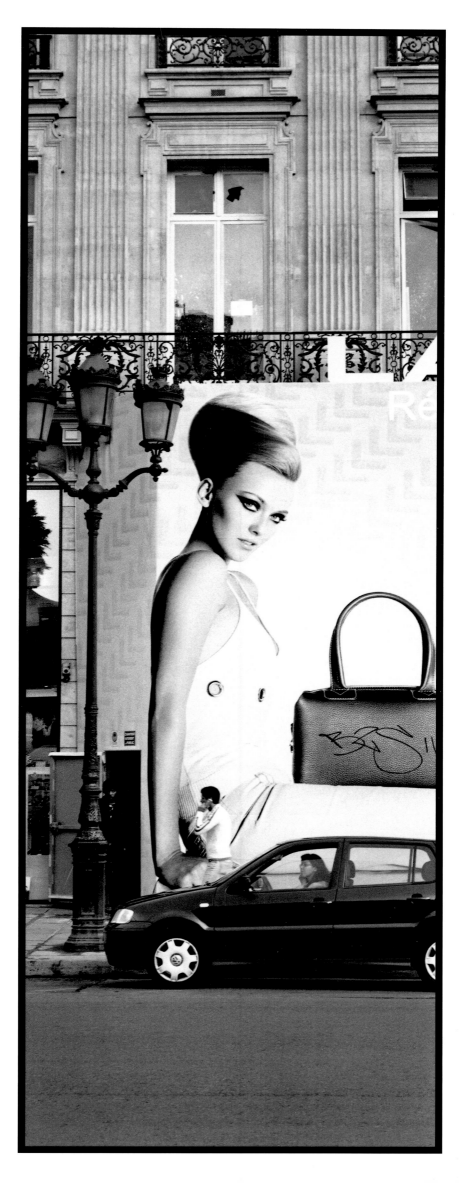

A Paris, il y a des impôts sur tout,
on y vend tout, on y fabrique tout,
même le succès.

In Paris, there are taxes on
everything, anything and
everything is for sale, and
anything can be manufactured,
even success.

Honoré de Balzac, Ecrivain / Poète

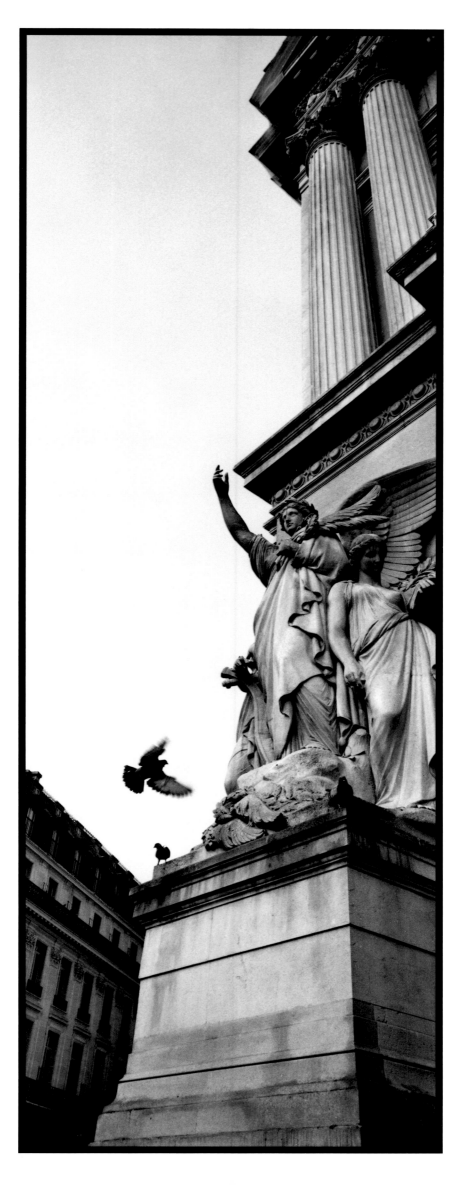

Dieu a inventé le Parisien pour que les étrangers ne puissent rien comprendre aux Français.

God invented Parisians so that foreigners would be unable to understand the French.

Alexandre Dumas, Ecrivain

A Paris, lorsque deux véhicules
ont leur pare-chocs éloignés de
vingt centimètres, c'est considéré
comme une place de parking.

In Paris, a twenty-centimeter
space between the fenders
of two cars is considered a
parking space.

Anonyme

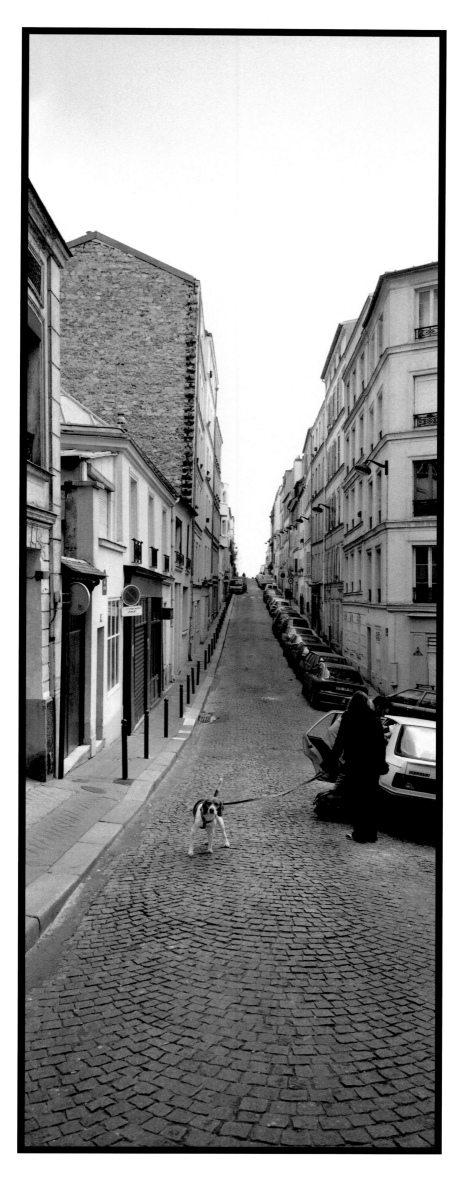

Une inclination particulière pour
ses rues inclinées: Montmartre,
la montagne Sainte Geneviève,
les hauts du Père Lachaise,
mes premières nuits parisiennes
en pente douce.

A particular inclination toward
sloping streets: Montmartre, the
Sainte Geneviève mountain, the
heights of Père Lachaise, my first
nights in Paris on a gentle slope.

Katia Kulawick, Journaliste

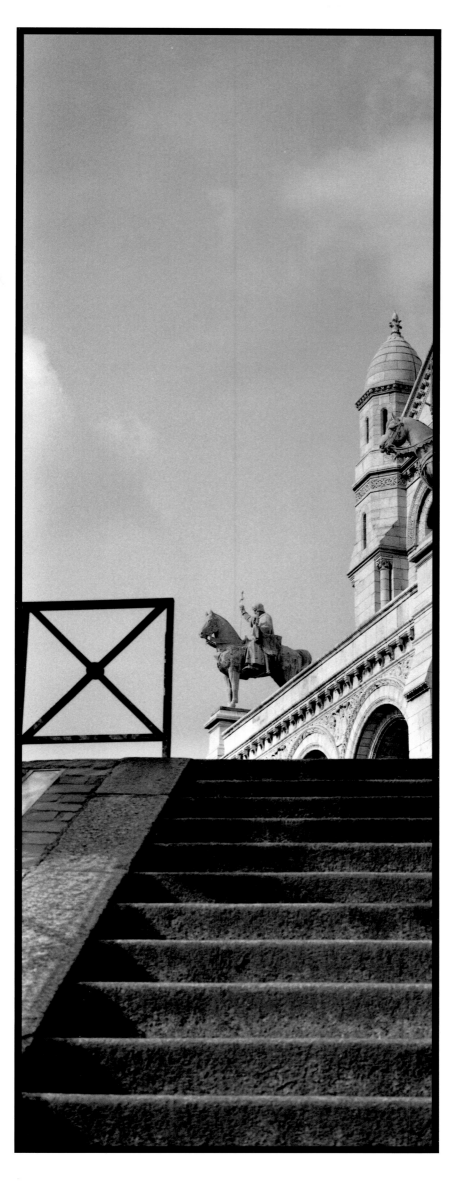

J'aime Paris en été,
quand ça crépite.

I love Paris in the summer,
when it sizzles.

Cole Porter, Musicien / Compositeur

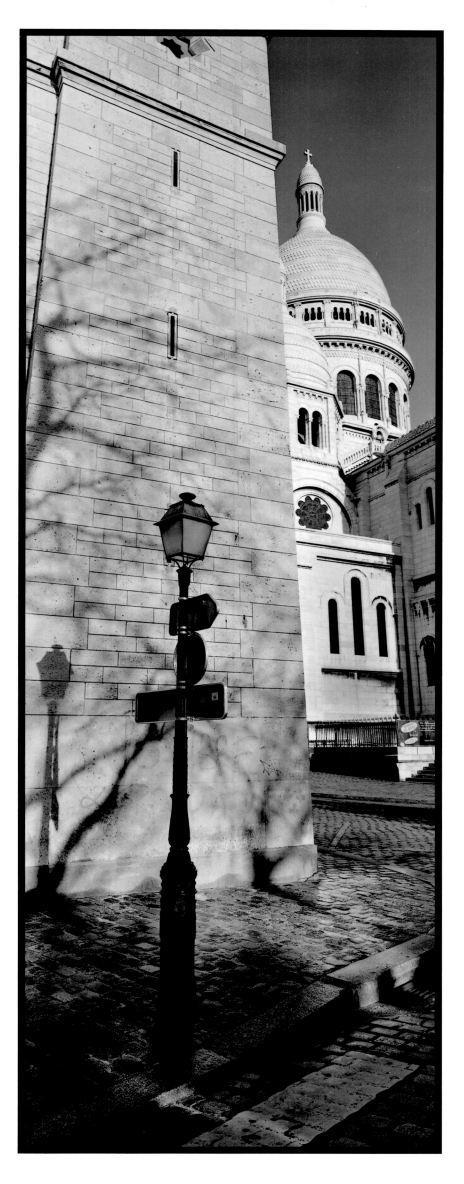

La douceur et l'amour, la richesse et l'honneur font à Paris, séjour.

Sweetness and love, richness and honor are made in Paris.

Robert Garnier, Poète

Quelquefois, j'aimerais
bien que Paris devienne moche.
Un peu glauque où abandonné.
Moins beau, moins triomphant.
Plus à moi. Quelquefois
seulement.

Sometimes I think I would like
Paris to become ugly. A little
shabby or abandoned. Less
beautiful, less triumphant. More
mine. But only sometimes.

Daniel Grand-Clément, Auteur

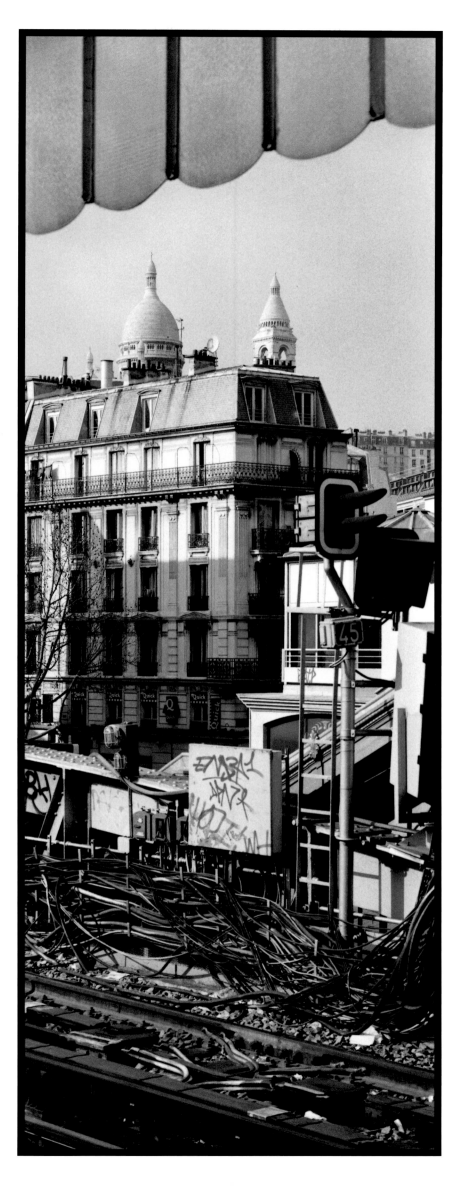

Si vous voulez visiter Paris, le mieux est d'y aller en août, lorsqu'il n'y a pas de Français.

If you want to visit Paris, the best time to go is during August, when there aren't any French people there.

Kenneth Stilling

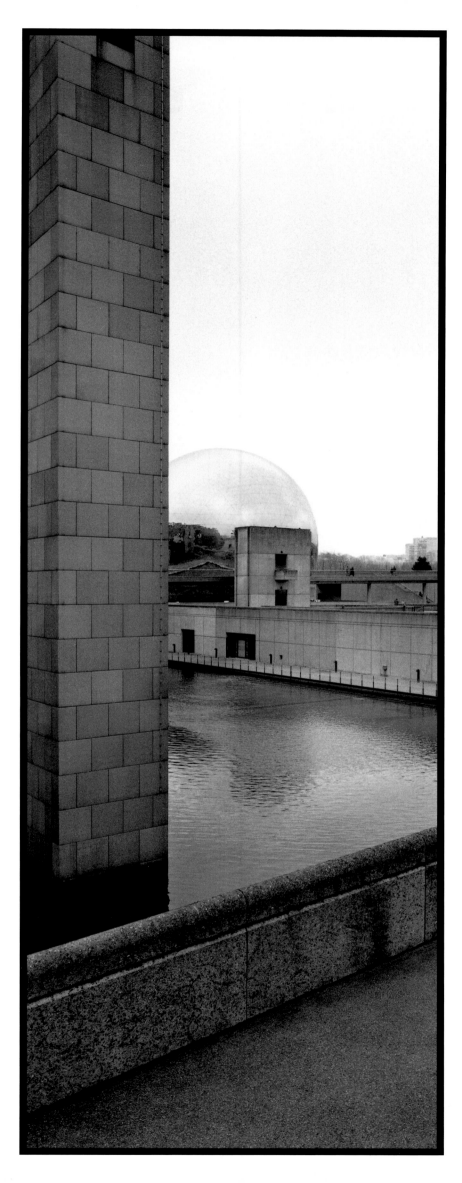

**Paris est le centre de la
dissipation, et les gens les plus
oisifs par goût et par état y sont
peut-être les plus occupés.**

Paris is the center of dissipation,
and people who are the most idle,
whether by nature or by choice,
are perhaps the busiest people there.

Charles Pinot Duclos, Poète

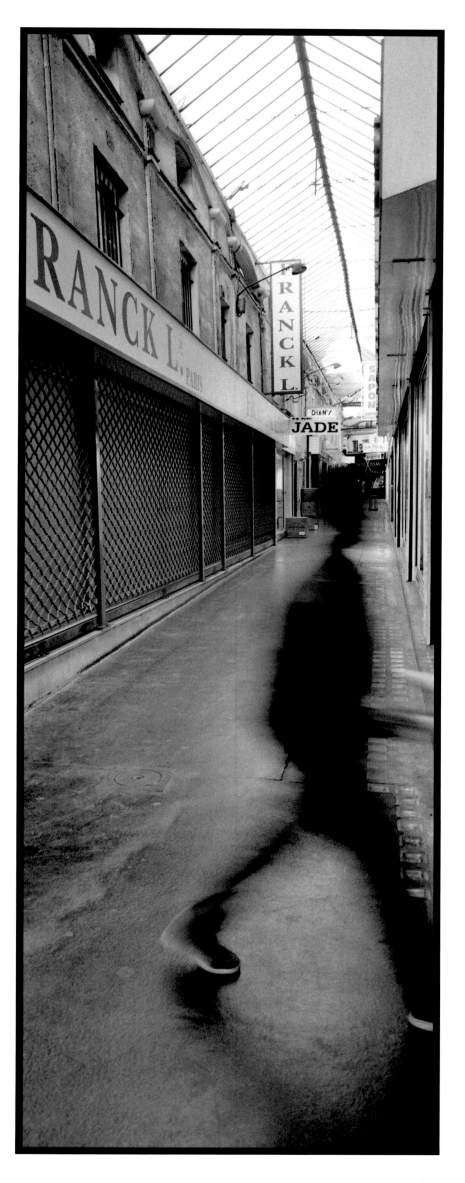

J'adore les Français car, même lorsqu'ils vous insultent, ils le font poliment.

I like Frenchmen very much, because even when they insult you they do it so nicely.

Josephine Baker, Chanteuse de variétés

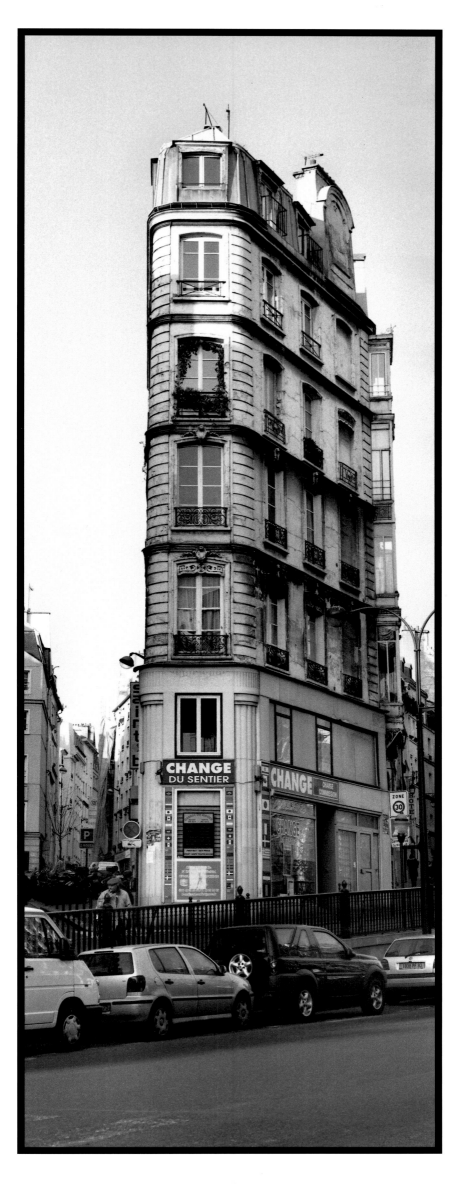

Oh! Que Paris c'est loin, Paris c'est loin, Paris c'est grand pour un p'tit émigrant.

Oh! How far Paris is, how far Paris is, how big Paris is for a little emigrant.

Gilbert Bécaud, Auteur / Compositeur

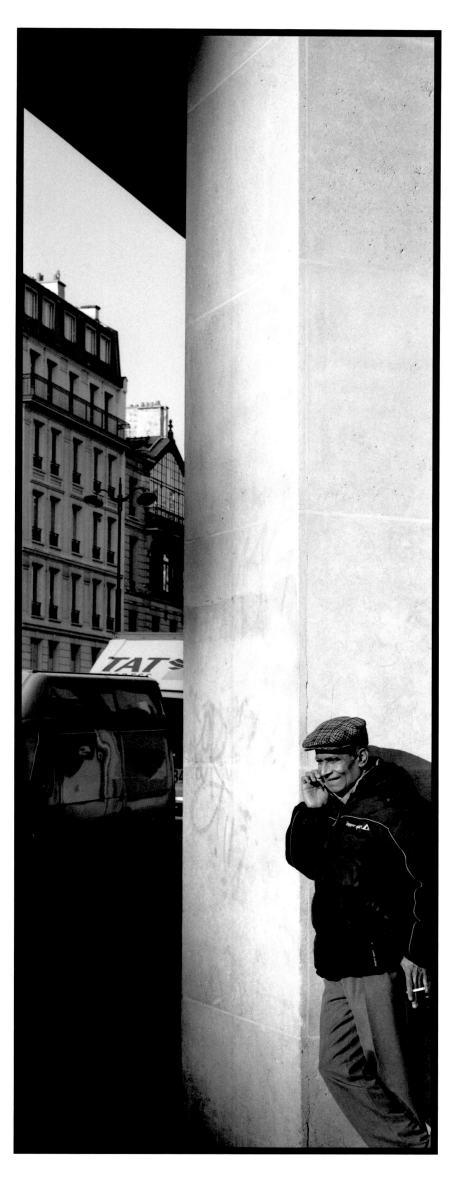

Paris s'éveille, je m'émerveille!

Paris is waking up, and I am
filled with wonder!

Olivier Gossart, Designer

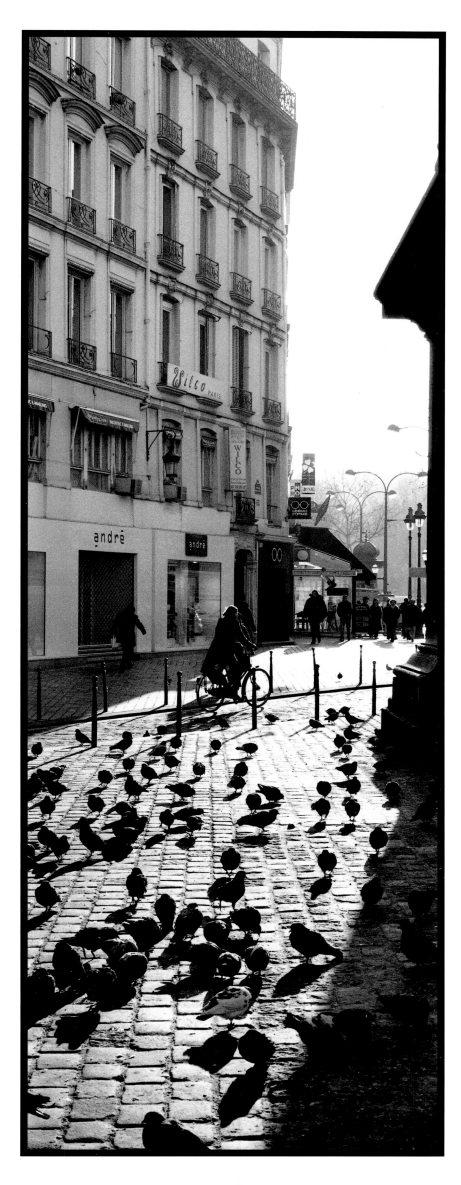

Comme artiste on n'a en Europe d'autre patrie que Paris.

As an artist, a man has no home in Europe save in Paris.

Friedrich Wilhelm Nietzsche, Philosophe

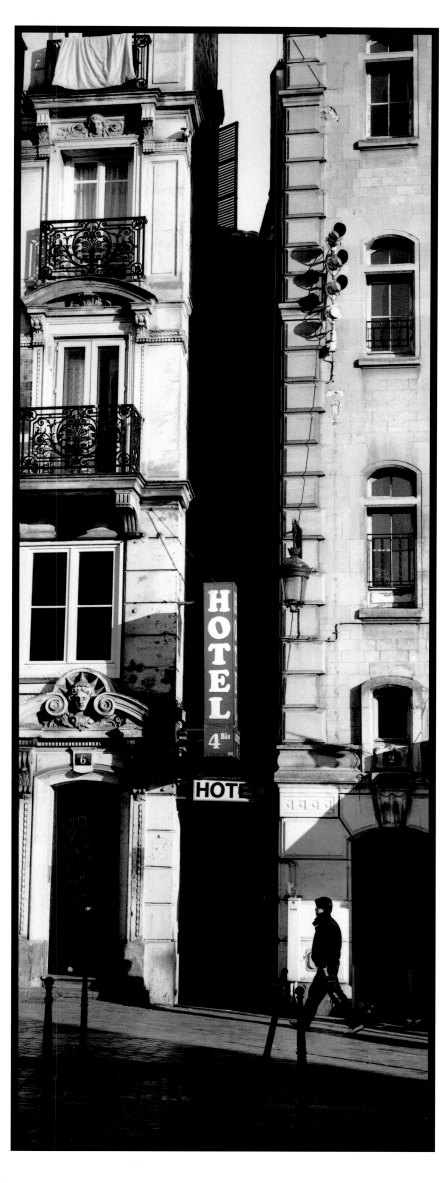

Paris change! Mais rien dans ma mélancolie n'a bougé!

Paris changes! But my melancholy has not changed at all!

Charles Baudelaire, Poète

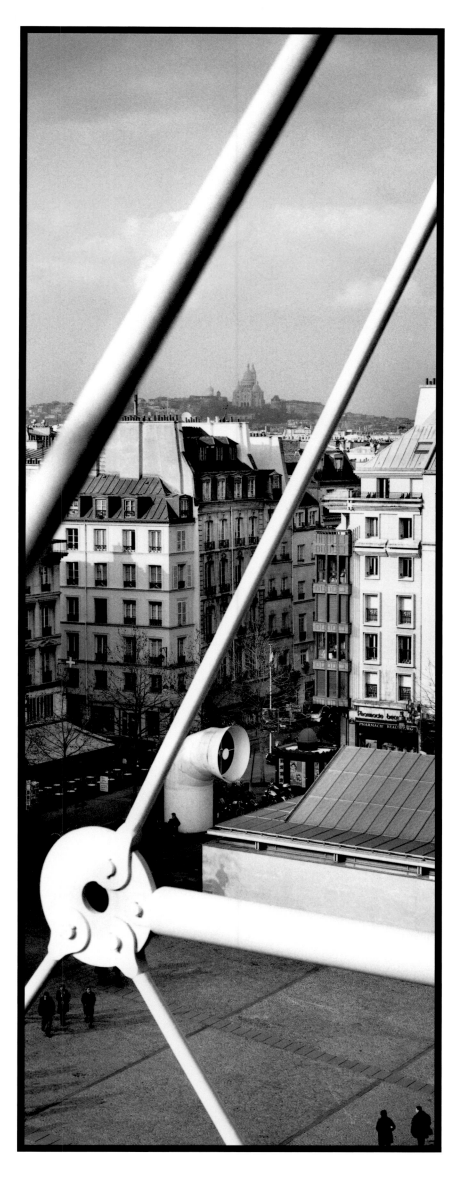

Se promener à Paris, c'est voyager à travers le temps.

Walking in Paris is like a trip through time.

Jean-Marie Monthiers, Architecte

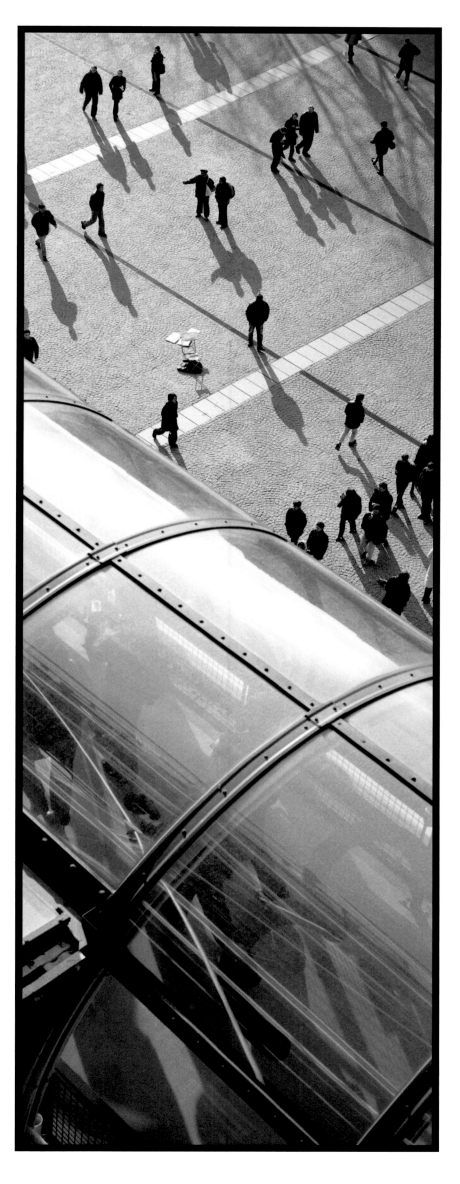

Toujours Paris s'écrie et gronde,
nul ne sait, question profonde,
ce que perdrait le bruît du monde,
le jour où Paris se tairait.

Paris is always crying out and
muttering, no one can answer the
profound question of what the
noise of the world will lose on the
day Paris is quiet.

Victor Hugo, Poète

Tout afflue à Paris.

Everything flows toward Paris.

Jean-Jacques Rousseau, Philosophe

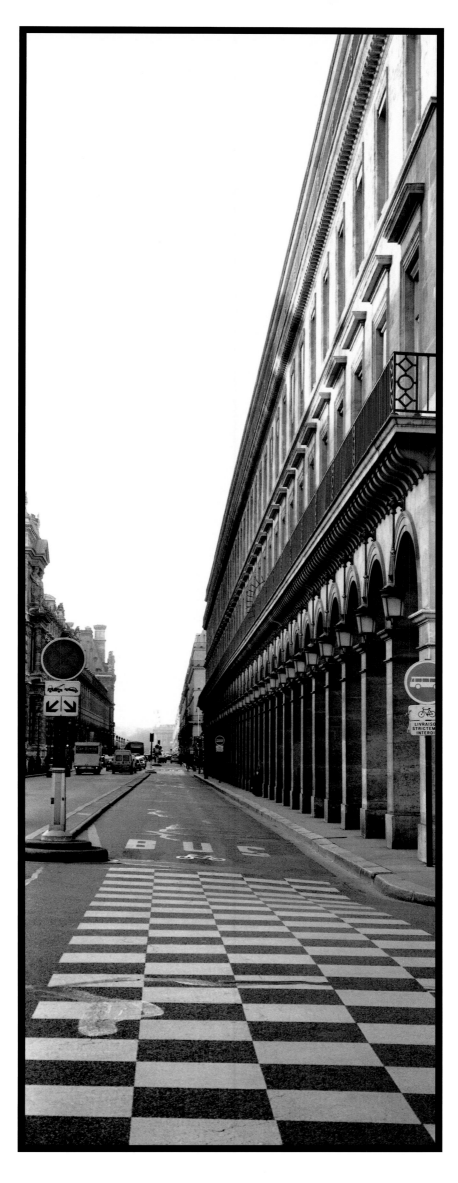

A Paris, on ne peut échapper au passé. Mais le passé et le présent se mêlent tant et si bien que cela n'a rien d'accablant. C'est ça qui est extroardinaire.

You can't escape the past in Paris, and yet what's so wonderful about it is that the past and the present intermingle so intangibly that it doesn't seem to burden.

Allen Ginsberg, Poète / Ecrivain

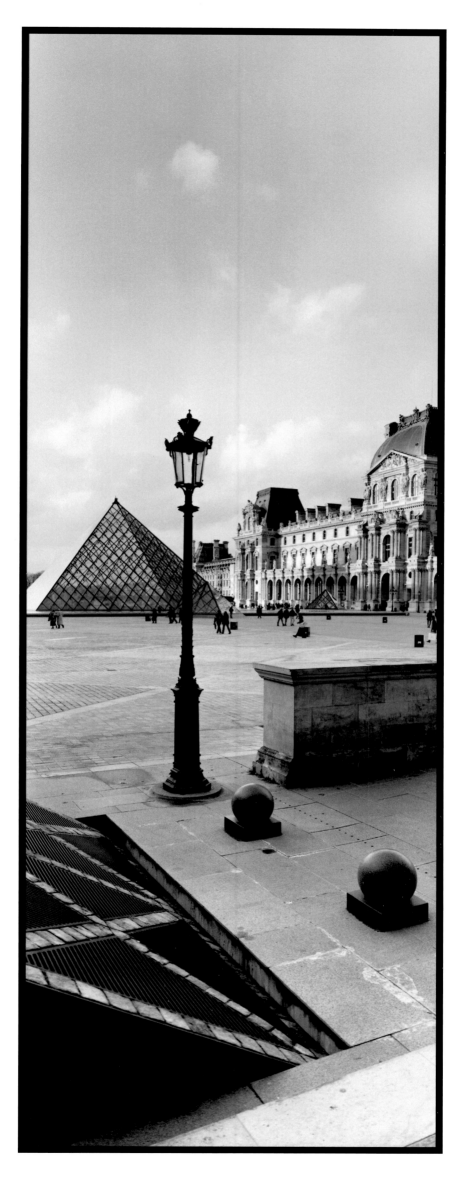

**A Paris, les seuls endroits où je
suis tranquille sont les musées.**

The only places where
I find peace in Paris are
in the museums.

Gerhard Vormwald, Artiste

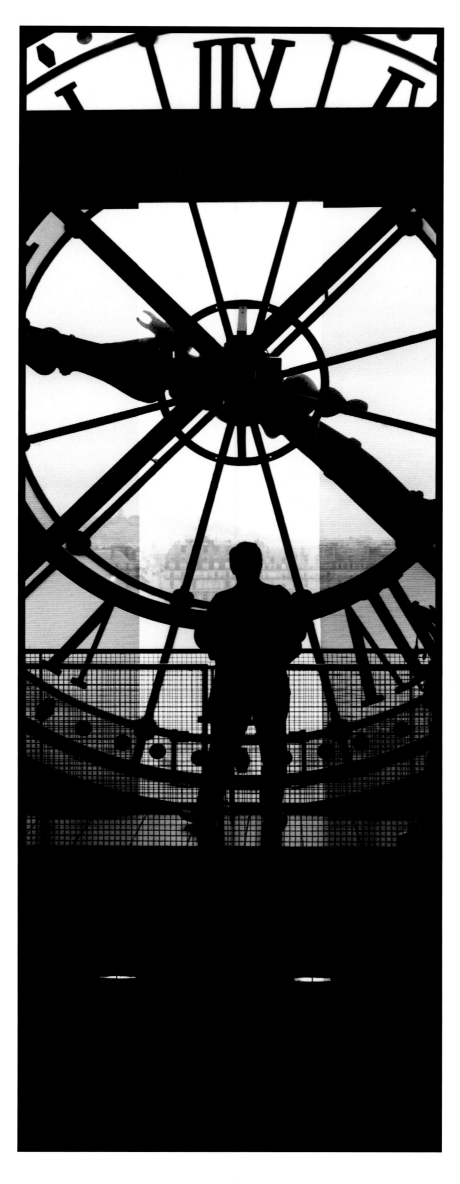

La dynamique nerveuse de Paris
établira les orientations rythmiques,
éthiques et esthétiques des temps
à venir.

The tense dynamics of Paris
will set the rhythm, ethical
and aesthetic directions of the
days to come.

Olga Sviblova, Directrice, Maison de la Photographie, Moscou

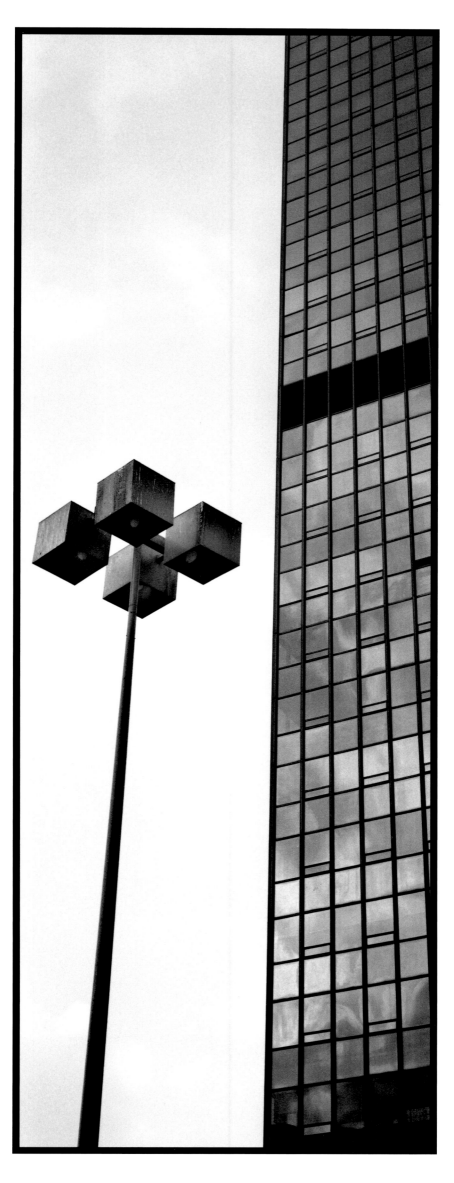

Si, jeune homme, vous avez
eu la chance d'y habiter, Paris
demeurera en vous où que
vous alliez, car Paris est une
fête itinérante.

If you are lucky enough to have
lived in Paris as a young man,
then wherever you go for the rest
of your life, it stays with you,
for Paris is a moveable feast.

Ernest Hemingway, Ecrivain

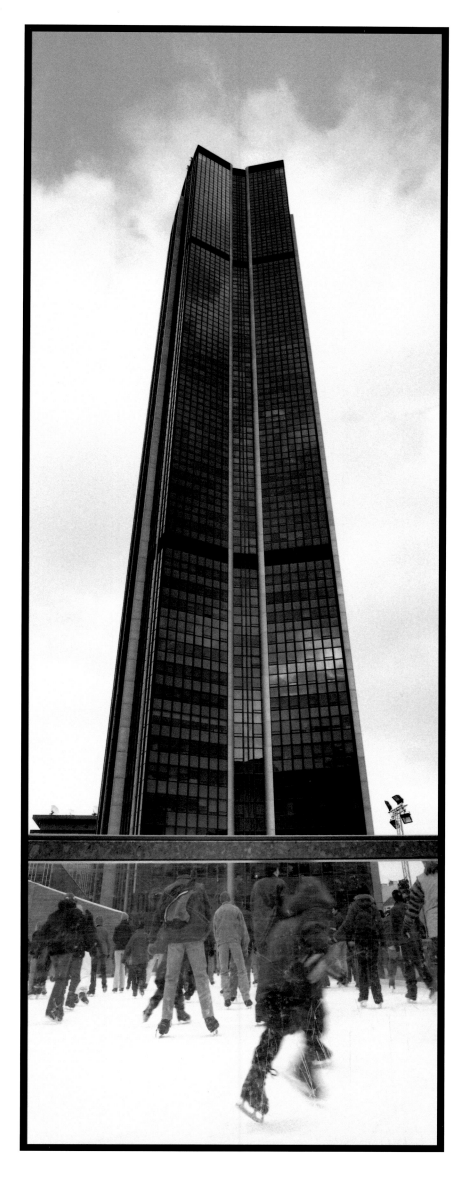

Le charme humé au détour d'une cour intérieure, le bouillonnement d'un quartier populaire, le raffinement cristallin de ses avenues profilées, le luxe discret de ses hôtels particuliers... Paris vibre et tressaille de mille émotions humaines.

The charm one can breathe in within an interior courtyard, the bustle of a working-class neighborhood, the crystalline refinement of its streamlined streets, the discreet luxury of its exceptional hotels... Paris quivers and shakes with a thousand human emotions.

Marie le Fort, Directrice Artistique

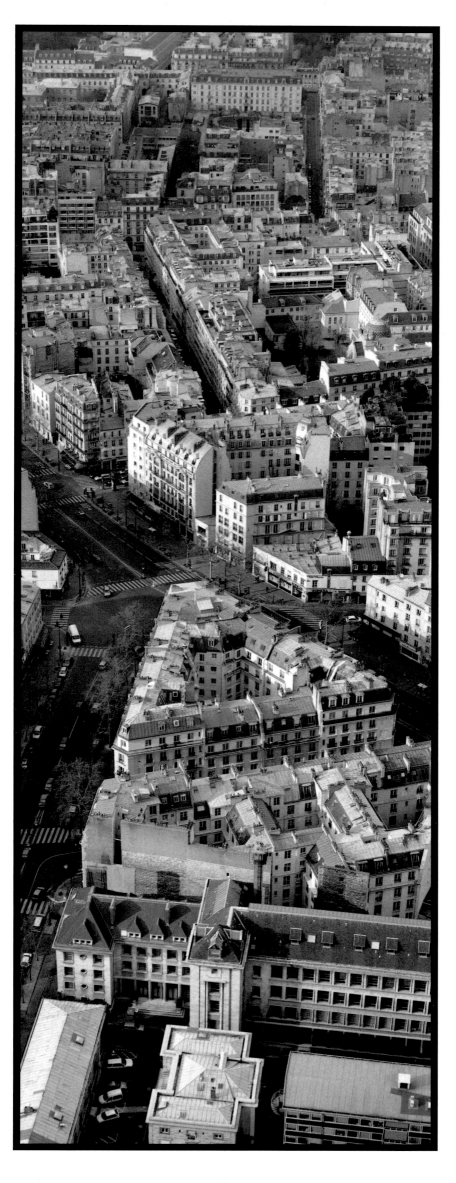

Le métro de Paris, gigantesque ver luisant, sur les toits de Paris, a tissé des fils d'argent.

The Paris métro, a gigantic glistening silkworm that has spun silver threads over the roofs of Paris.

Edith Piaf, Chanteuse

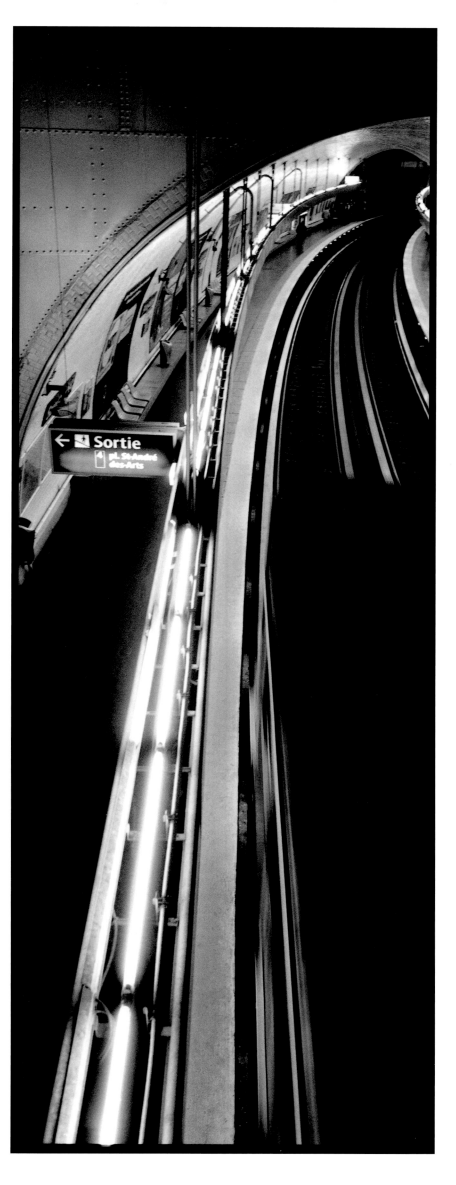

A Paris, tremper un croissant dans son café-crème nous fait parisien!

In Paris, dunking a croissant in one's café-crème makes one Parisian!

Gérard Benoît à la Guillaume, Photographe

Dans l'ombre des rues étroites de Saint-Germain, je suis tombé amoureux de son parfum.

In the shadows of the narrow streets of Saint-Germain I fell in love with her perfume.

Eric Baronne, Athlete

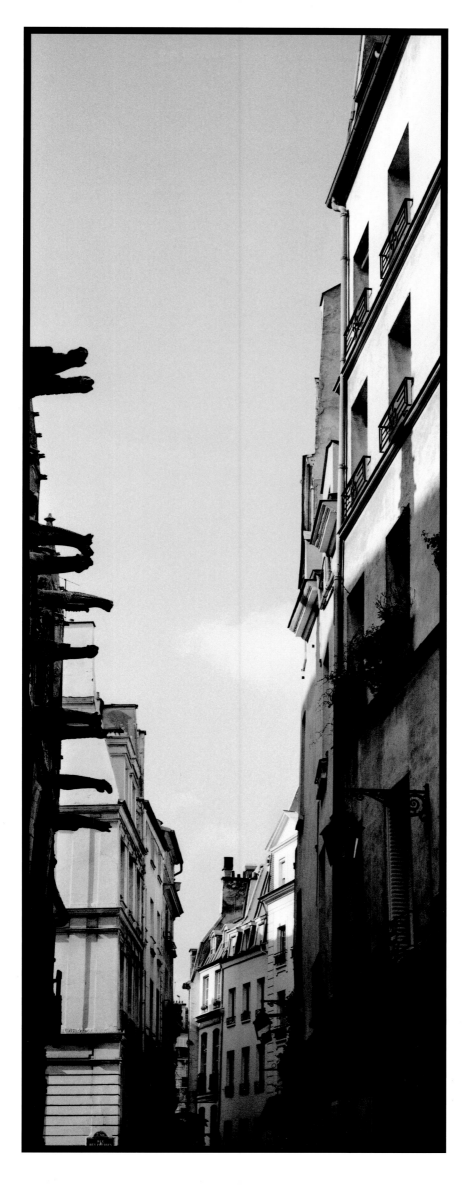

Elle: Où m'emmenez-vous?
Lui: À Paris.
Elle: Je vous aime . . .

She: Where are you taking me?
He: To Paris.
She: I love you. . .

Christiane Bop, Comédienne

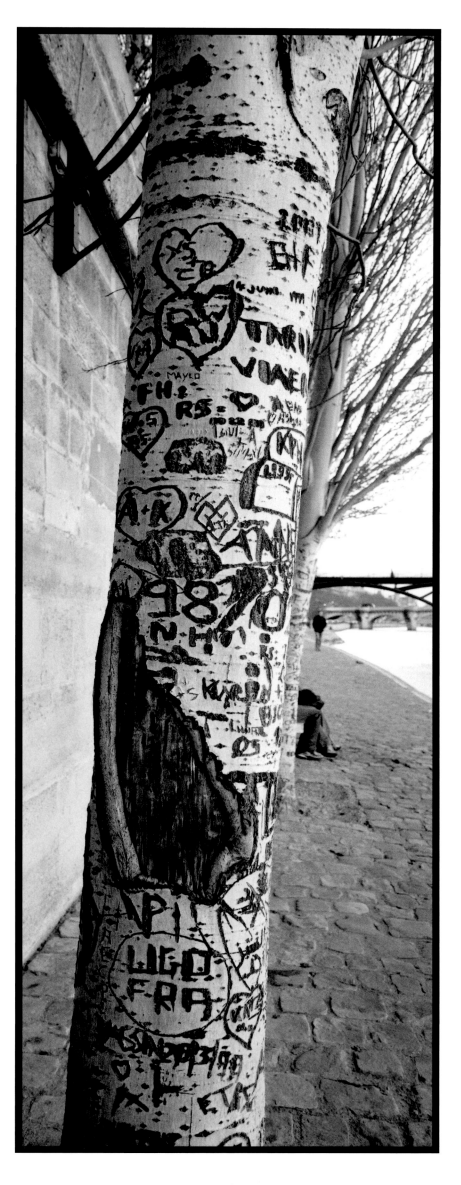

Paris sera bientôt la seule
ville au monde où, au réveil,
on pourra entendre les
petits oiseaux tousser.

Paris will soon be the only
city in the world where when
one wakes up one can hear
the little birds coughing.

Pierre Doris, Chansonnier

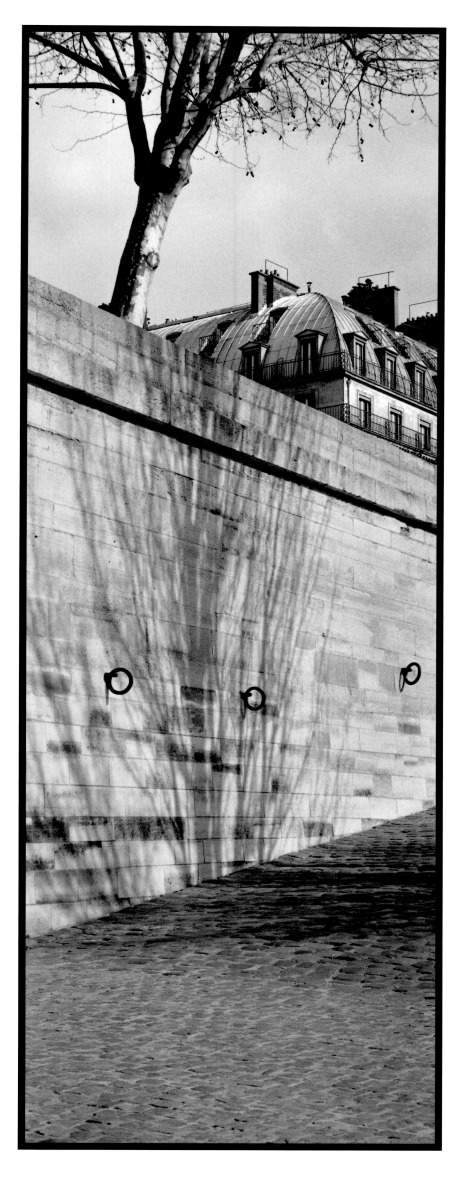

**On n'a jamais l'intention
d'aller nulle part à Paris: on
ira peut-être faire un tour.**

No one ever intends to actually go
anywhere in Paris: but one might
go for a walk around.

Alain Schifres, Ecrivain

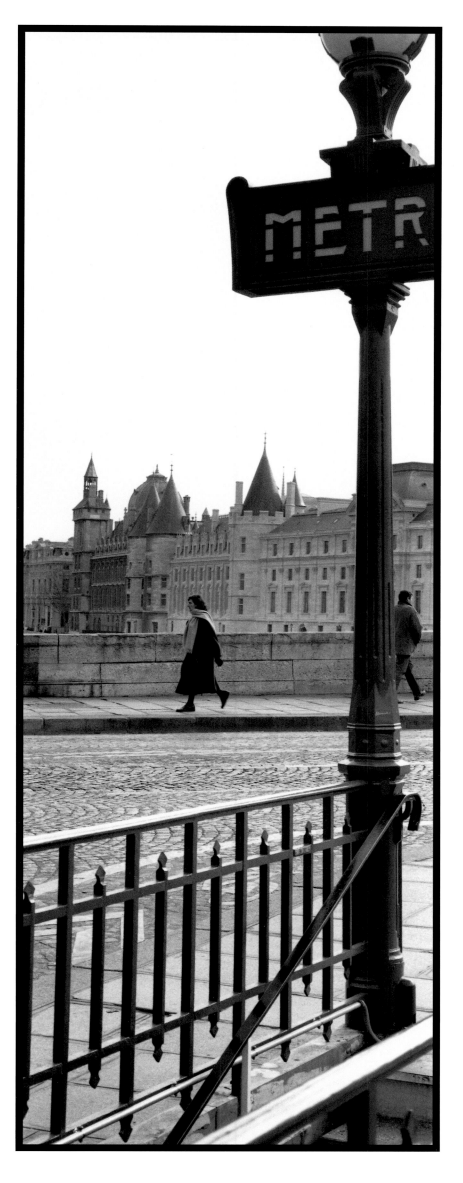

**Traverser le Pont Neuf, voilà qui
réconcilie avec Paris!**

Crossing the Pont Neuf,
one is reconciled with Paris!

Philippe Muyl, Réalisateur

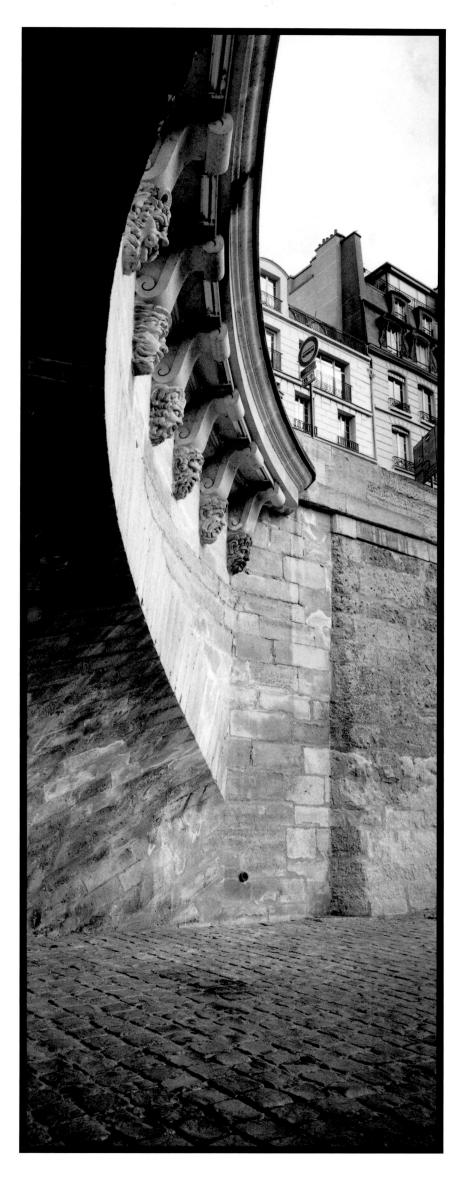

Savez-vous pourquoi il y a tant d'églises à Paris? C'est pour permettre de faire une prière avant de traverser la rue.

Do you know why there are so many churches in Paris? It's so that you can pray before you cross the street.

Art Buchwald, Auteur / Journaliste

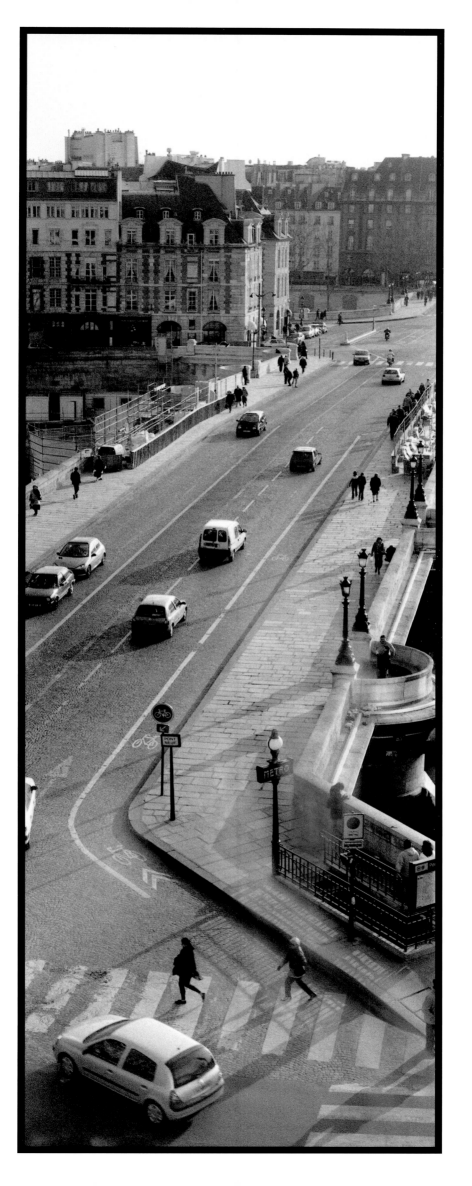

Les mains dans les mains
restons face à face tandis que
sous le pont de nos bras passe,
des éternels regards l'onde si lasse.

Hand in hand, we remain facing one
another while a wave of eternal
glances passes beneath the bridge
formed by our arms.

Guillaume Apollinaìre, Poète

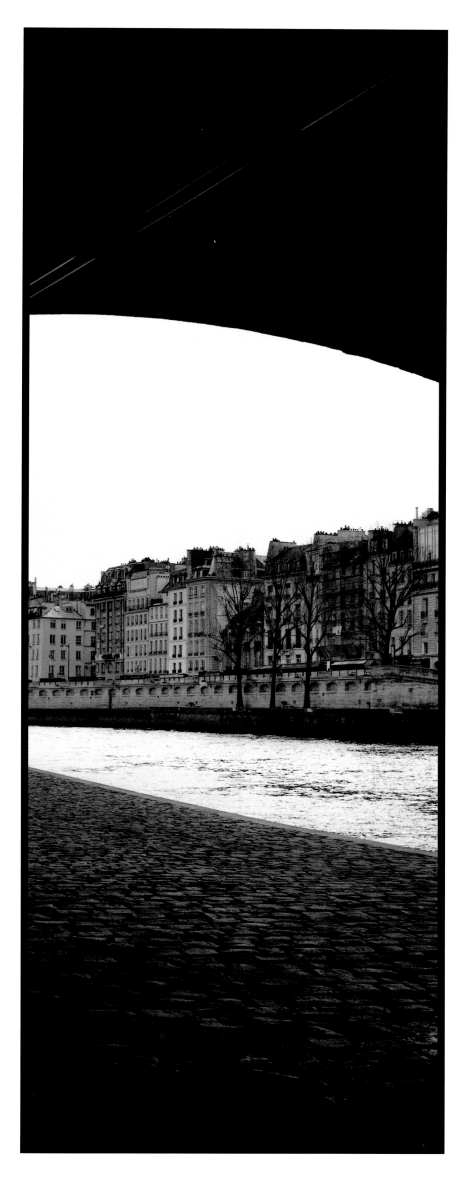

La Côte d'Azur est la serre où poussent les racines. Paris est la boutique où on vend les fleurs.

The Côte d'Azur is the greenhouse where roots grow. Paris is the shop where the flowers are sold.

Jean Cocteau, Auteur

Si les bars à Londres avaient des terrasses comme à Paris, on y boirait des verres de pluie.

If the bars in London had terraces like in Paris, one would end up drinking glasses full of rainwater at them.

Somerset Maugham, Poète

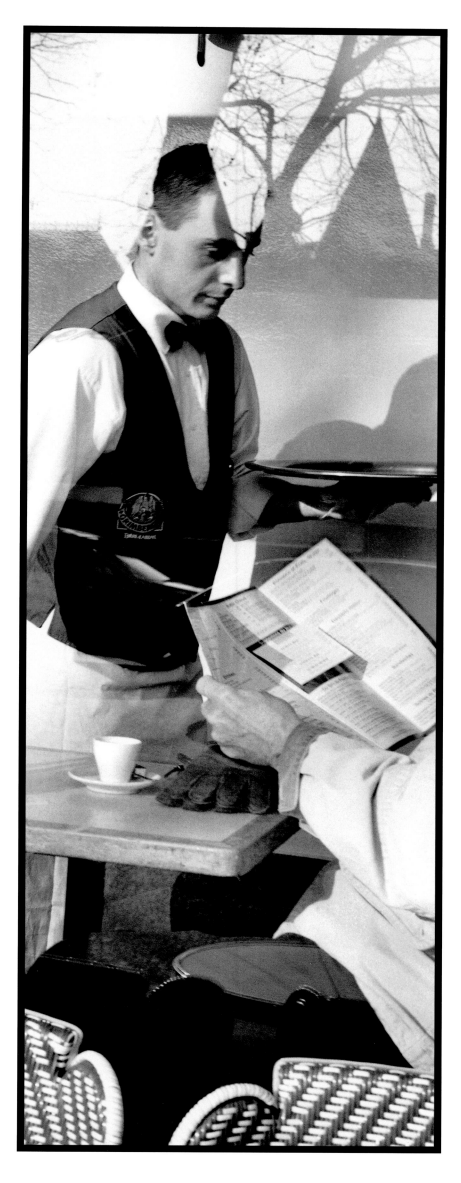

Paris est la capitale des divines tentations.

Paris is the capital
of divine temptations.

Zoé Valdès, Romancière

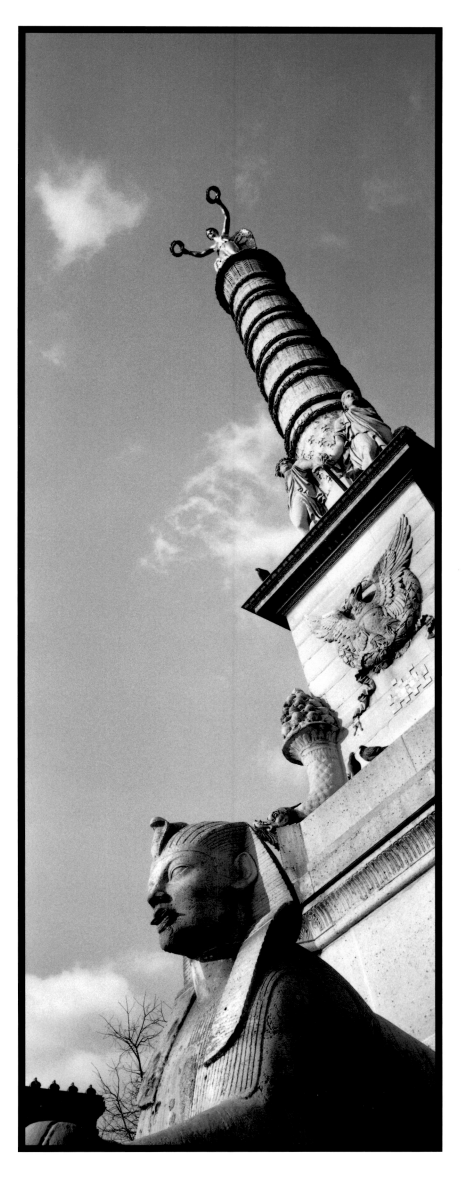

O les longues rues amères
autrefois et le temps où
j'étais seul et un! La marche
dans Paris, cette longue rue qui
descend vers Notre Dame!

Oh, those long, bitter streets in
the past, and the time when
I was all alone! Walking through
Paris down that long street that
runs down to Notre Dame!

Paul Claudel, Ecrivain

Poésie d'un vaisseau de pierre ancré au milieu de la Seine.

The poetry of a ship made of stone, at anchor in the middle of the Seine.

Anonyme

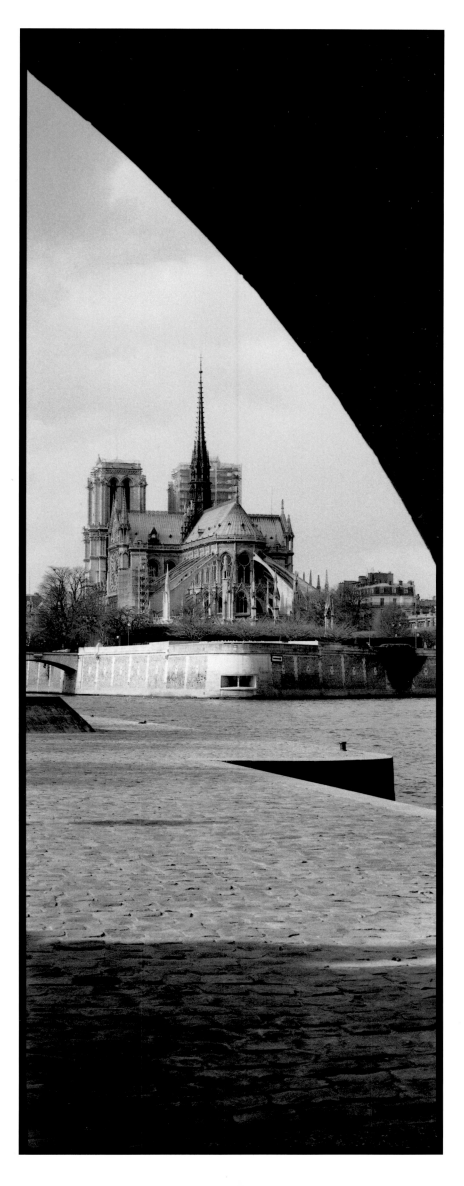

Dedans Paris avec toute science,
toutes vertus, avecque sapience
finalement, c'est paradis terrestre,
ne reste plus que paradis céleste.

Paris, with all its knowledge,
all its virtues, all its wisdom, is an
earthly paradise. Nothing remains but
the celestial one.

Pierre Grognet, Poète

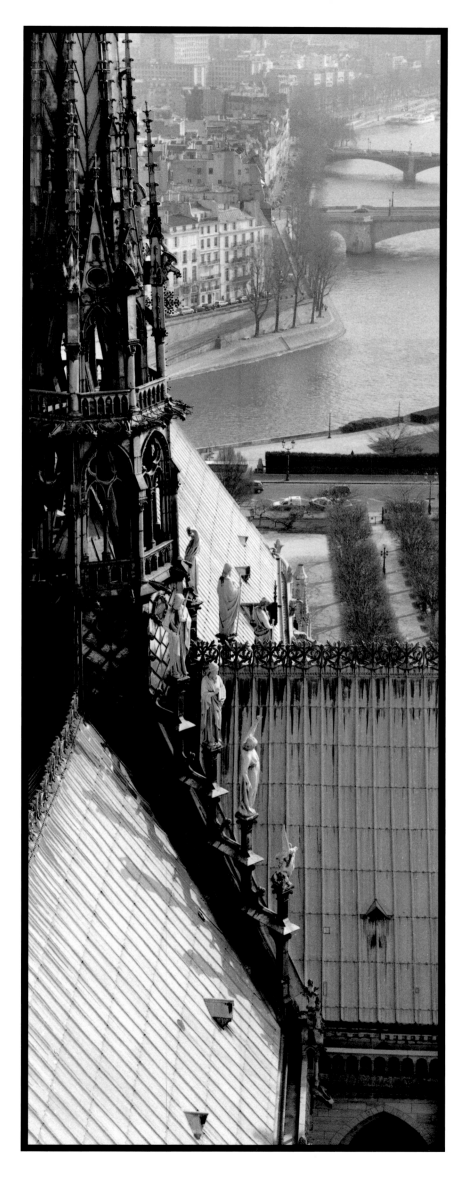

J'aime Paris et la mer…
je rêve de Paris sur mer.

I love Paris and the sea…
I dream of Paris at the seaside.

Maxime Préaud, Auteur

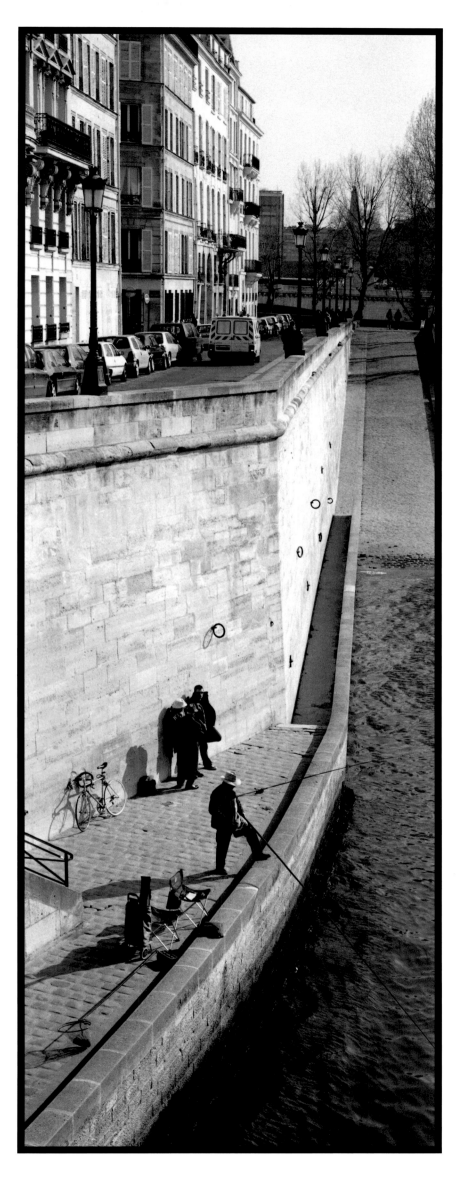

Paris d'en haut
gouttelettes
larmes d'en bas
Paris ruisselle
sur Seine jusque chez moi
Paris si belle.

Paris, with drips
from above and
tears from below,
Paris streams
along the Seine to my home;
Paris, so beautiful.

Dominique Barra, Fabricant

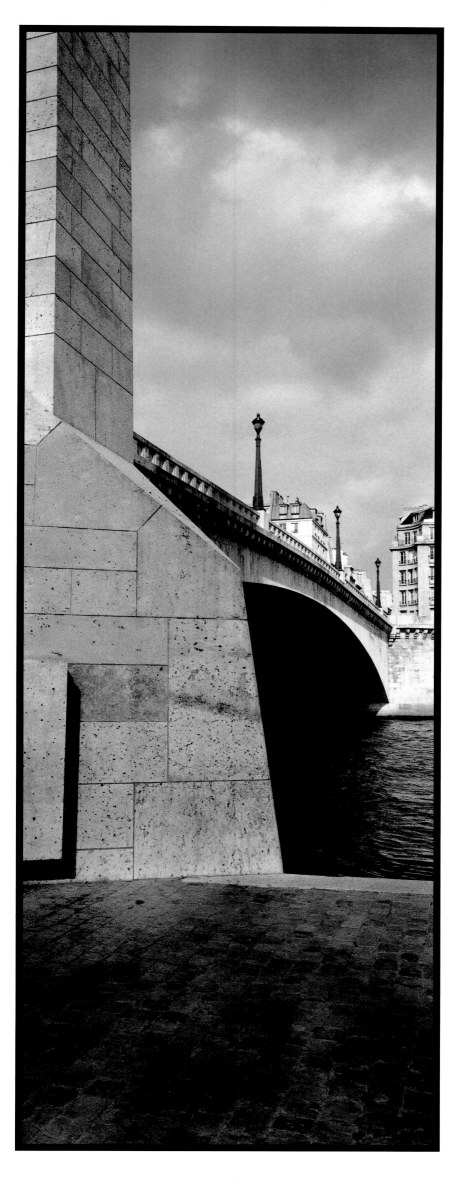

Les gens traverseront Paris
pour vous emprunter un livre.
Ils ne monteront pas un étage
pour vous le rendre.

People will go all the way across
Paris to borrow a book from you.
But they won't go up a single
flight of stairs to return it.

Georges Courteline, Ecrivain

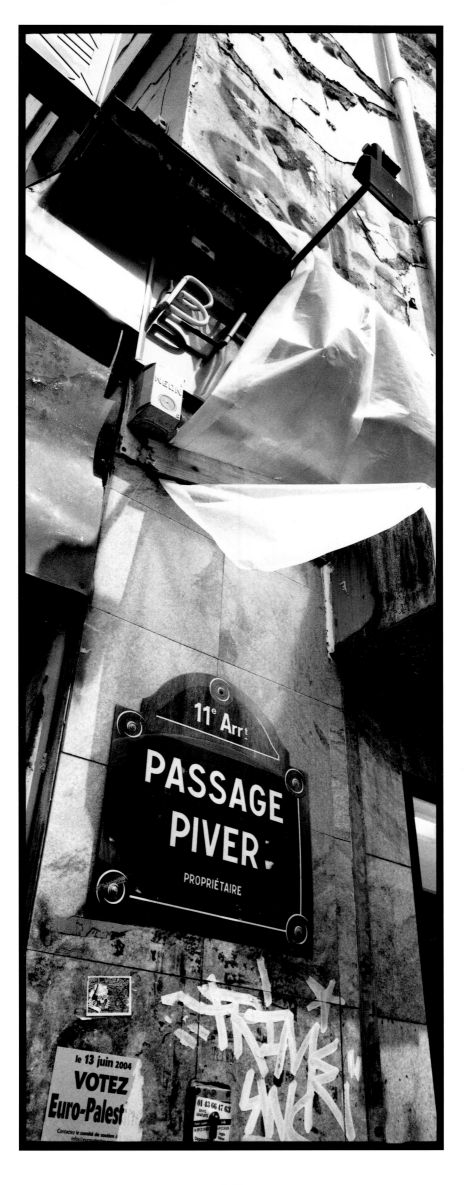

Les musées d'art de
Paris contiennent les
plus belles collections de
cadres jamais vues.

The art museums of Paris contain
the most beautiful collections of
frames ever seen.

Humphrey Davy, Chimiste

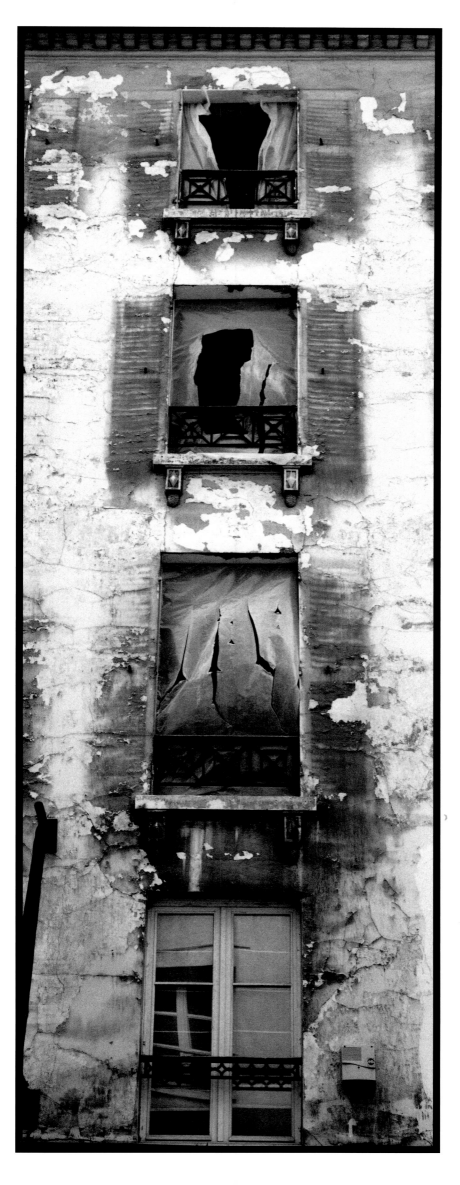

Il n'est que de parcourir tes rues, de passer tes
ponts, d'appréhender tes perspectives pour voir et
pour comprendre que durant des siècles personne
mieux que toi n'a su traduire dans la pierre,
l'esprit de l'homme et l'esprit du temps.

One has to go through your streets, cross
your bridges, take in your perspectives,
to see and understand that, through the centuries,
no one has known better than you how to translate
into brick and mortar the spirit of man and the
spirit of time...

Eric Dupont, Galeriste

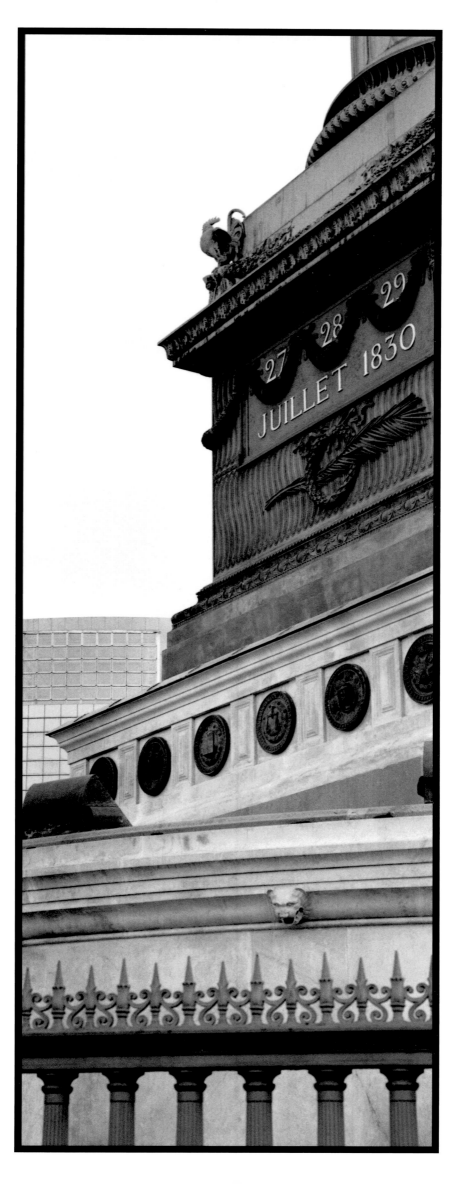

**Paris, où le modernisme
est né et les têtes du roi
et de la reine ont roulé.**

Paris, where modernism was
born and the heads of the king
and queen rolled.

Paul Pagk, Peintre

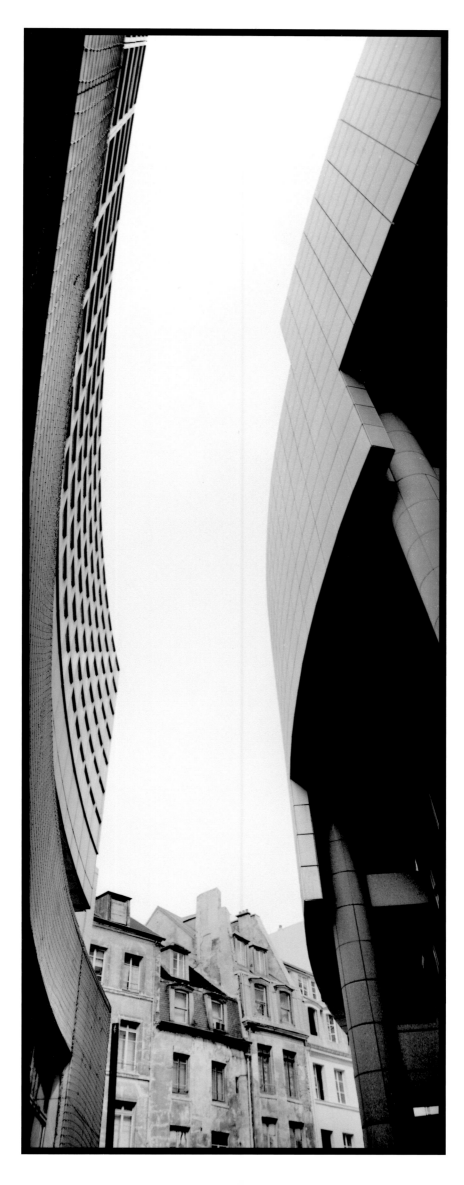

**Tant de choses déjà oubliées,
tant oubliées, tant à oublier.**

So much forgotten already,
so much forgotten, so much
to forget.

Jim Morrison, Musicien / Poète

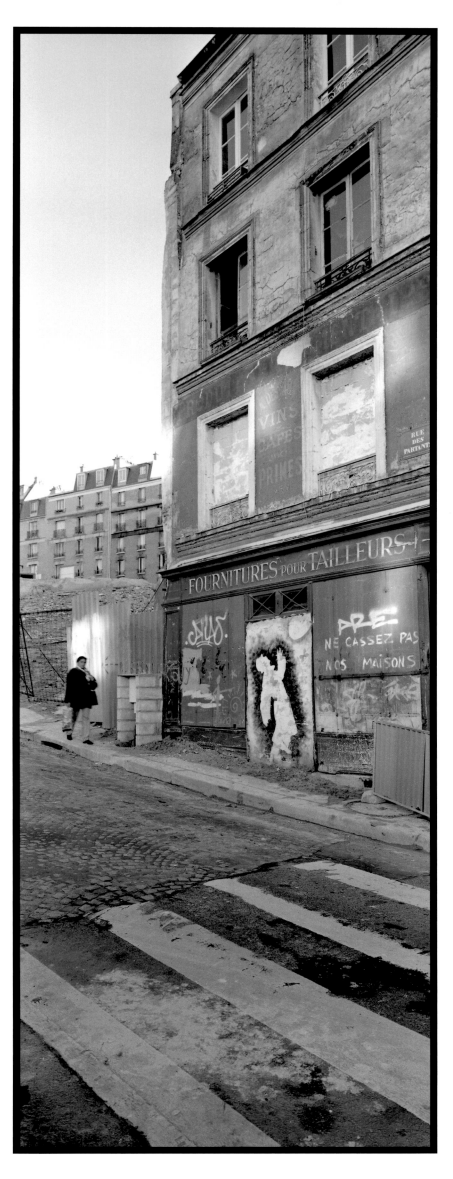

Un patio, une faille étroite
de marbre blanc, dans la
ligne de mire du chevet
de Notre Dame...

A patio, a narrow gap of white
marble in the line of sight of the
apse of Notre Dame...

Jean Nouvel, Architecte de l'Institut

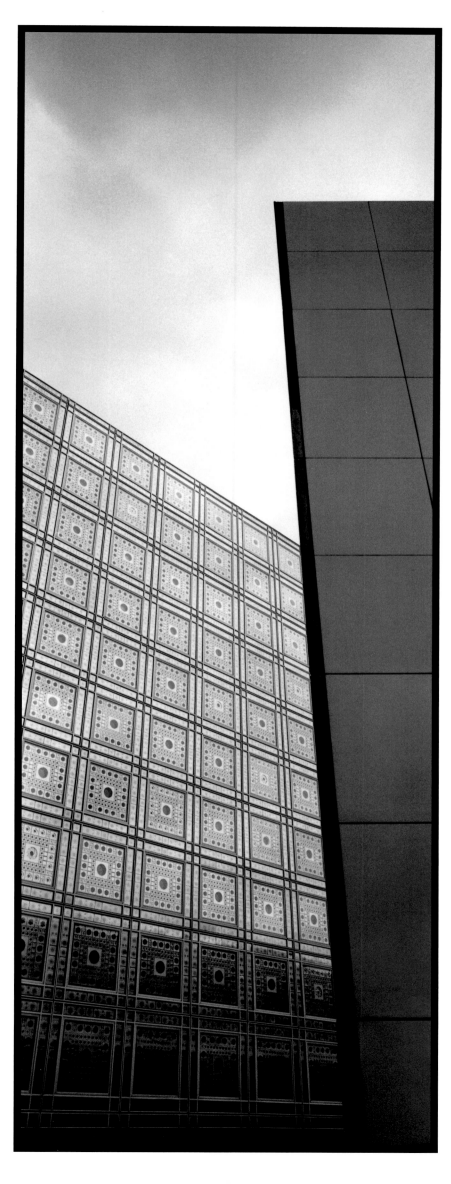

Tout ce que je désirais était de
me connecter aux humeurs de
Paris. La Beauté se dépeint;
alors, quand elle se dépeignait le
mieux, je photographiais.

All I wanted was to connect
my moods with those of Paris.
Beauty paints and when it
painted most, I shot.

Ernst Haas, Photographe

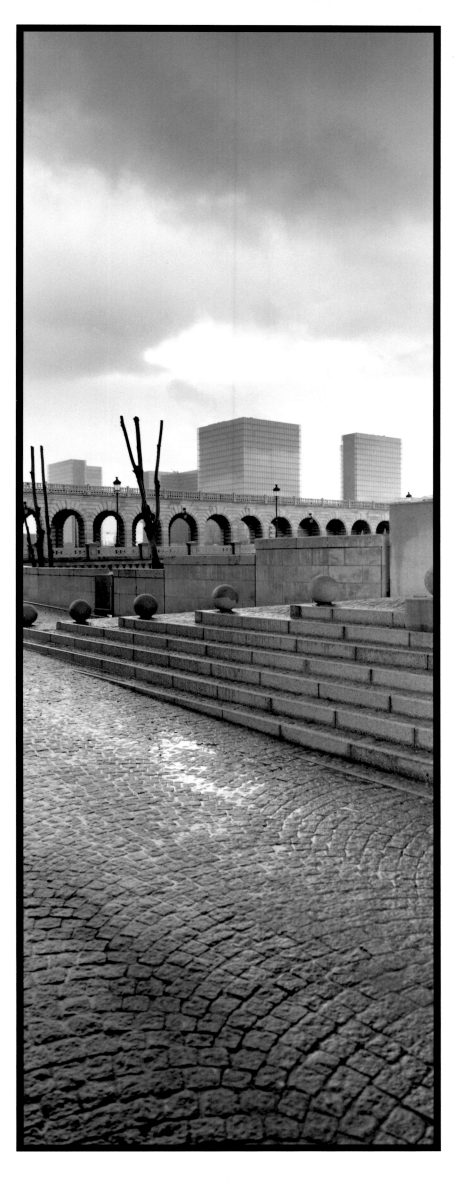

Je suis l'homme qui accompagna Jacqueline Kennedy à Paris, et ce fut une joie.

I am the man who accompanied Jacqueline Kennedy to Paris, and I have enjoyed it.

John Fitzgerald Kennedy, Président des Etats Unis

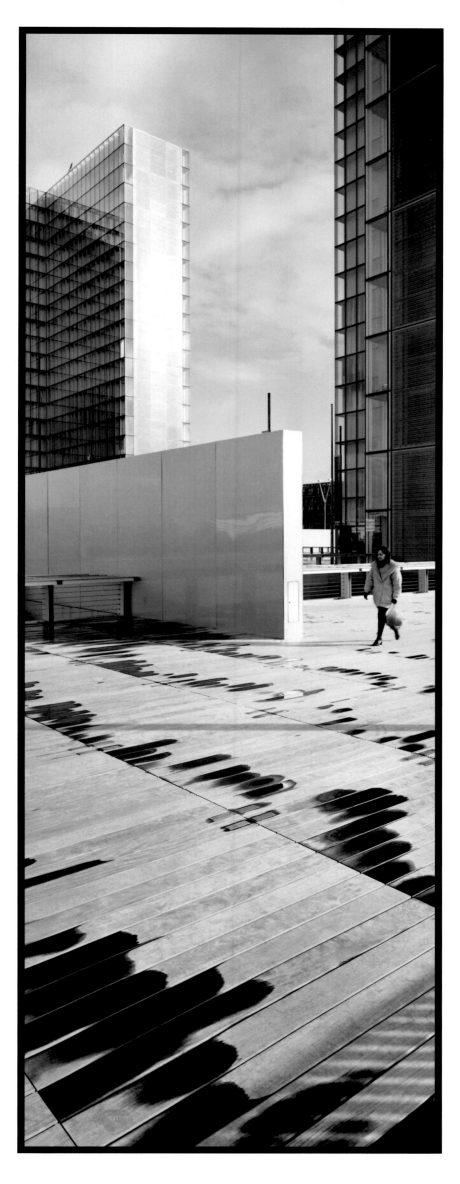

Paris est tout petit pour ceux qui s'aiment d'un aussi grand amour.

Paris is very small for those who love one another with such a great love.

Marcel Carné, Cinéaste

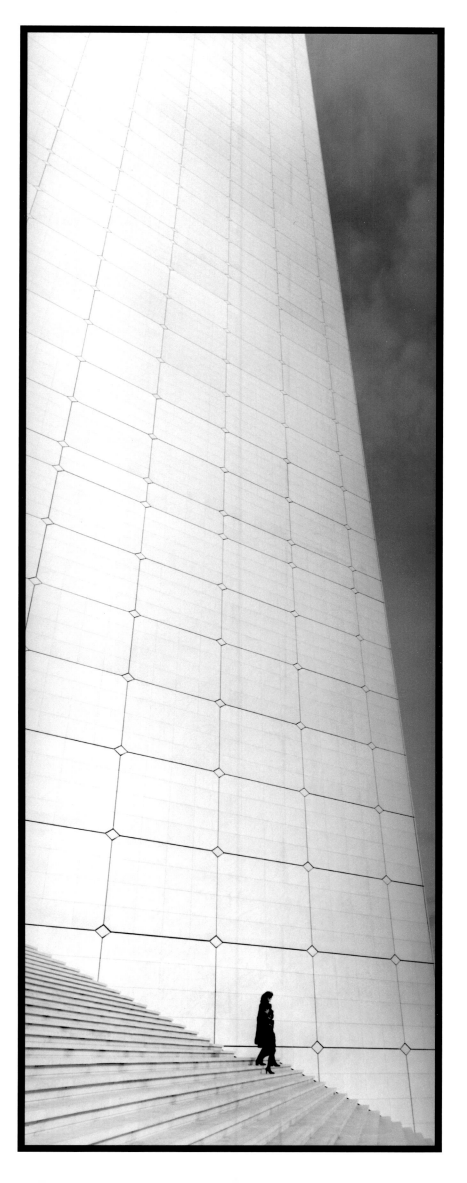

**L'Amérique est mon pays
et Paris, ma ville.**

America is my country and
Paris is my home town.

Gertrude Stein, Auteur

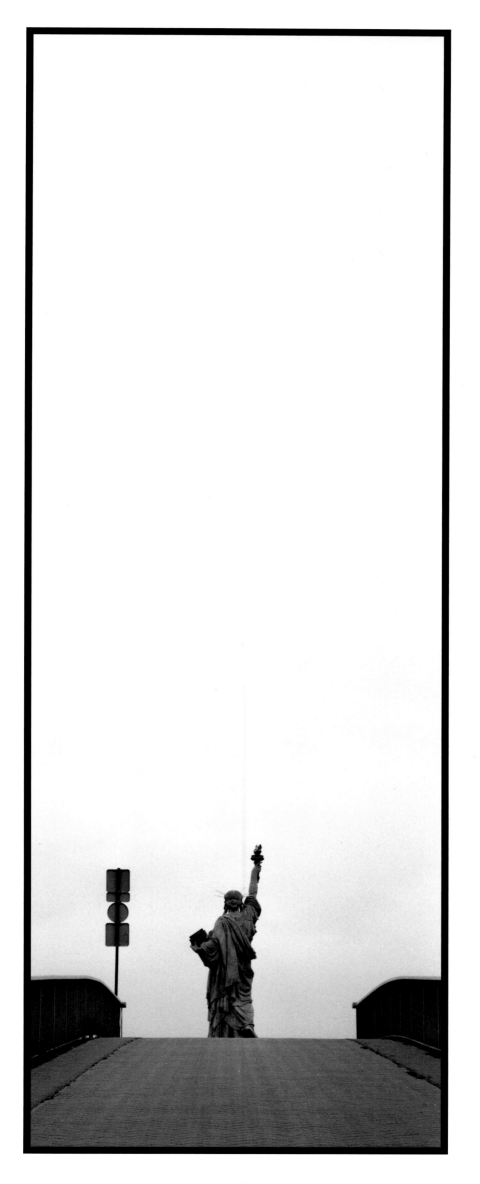

PARIS N'EST PAS VERTICALE
HORST HAMANN

«Paris n'est pas une ville verticale!» m'a-t-on quasiment reproché lors de ces dix dernières années d'exploration verticale de Paris. Et pas seulement les Français.

Visuellement, la tour Eiffel est toute en hauteur et dominante. Mais l'observateur ne peut rien ajouter à ça... La Tour Montparnasse et La Défense, peut-être, à la rigueur. Non, Paris est une ville plate et étendue, certainement pas haute et encore moins verticale. Mais là, c'est à mon tour de m'exprimer, avec ma façon de voir les choses, ma nuque tendue et mon oeil exercé par de longues années à New York (New York Vertical). Sensible aux perspectives verticales et équipé de mon nouvel appareil panoramique (Hasselblad X-Pan) qui convient parfaitement à ma façon de travailler, Paris, qui n'est assurément pas une ville verticale, est devenu mon nouveau défi.

La métropole française m'a toujours attiré. Il y a 25 ans déjà, il m'arrivait de faire l'école buissonnière: au volant de ma vieille coccinelle, je prenais la direction de Paris. J'y prenais un café au lait et quelques photos. De retour le soir, à Mannheim, je me vantais, preuves à l'appui: le reçu de mon café, et quelques pièces de francs français. Pour un lycéen de terminale originaire d'une petite ville de province et hanté par la nostalgie des contrées lointaines, c'était le chemin le plus court vers le vaste monde. La décision de participer à un voyage d'études (au cours duquel je pris mes premières photos parisiennes) me coûta ma place d'avant-centre au FV 09 Weinheim. Fritz Walter (mon cadet) me remplaça. Parfois, je me demande encore si je pris la bonne décision. Fritz Walter est devenu le meilleur buteur de la Bundesliga au VFB Stuttgart. Mes capacités de «shooter» furent dès lors mesurées selon d'autres critères.

A New York, je fis la rencontre de Marie (une Française!), qui devint ma femme. Pendant trois ans, nous habitâmes un petit appartement près des jardins du Luxembourg. Ainsi, je ne rompis jamais les liens avec Paris (malgré les sérieux doutes de mon professeur de français, qui me fit redoubler une année de lycée).

Lorsque je regarde mes anciennes photos de Paris, certaines occupent une place particulière dans l'armoire de mes trophées photographiques. De classiques et beaux souvenirs. D'autres, en revanche, les premières Paris Verticals, notamment, ressemblent à des ébauches qui manqueraient de maturité. Je ressentis la même chose au début de mon travail sur New York.

Mais aujourd'hui, je n'ai plus besoin de ville ou d'architecture verticale pour faire des photos verticales. Cette évolution apparut à New York (cf. New York Vertical, photographie page 59, Houston Street, 1993). Il y a huit ans, lors de mes travaux new-yorkais, je pris quelques photos de Hongkong: j'eus le sentiment qu'il s'agissait d'une pâle imitation du cycle new-yorkais. Bien entendu, Hongkong est une ville passionnante sur le plan visuel, mais sa silhouette et sa concrétisation photographique me faisaient trop penser aux perspectives new-yorkaises pour ressentir la moindre excitation et le plaisir que j'éprouvais à Manhattan.

Or, Paris est une toute autre histoire. Tout me poussait à aller plus loin. Pour apprécier à leur juste valeur la ville et ses particularités, il fallait me défaire de certaines habitudes visuelles. Il ne s'agissait plus de hauteur, ni de points de fuite vers le ciel... C'étaient des détails à hauteur des yeux qui m'attiraient. Une fissure dans un mur ou l'arche galbée d'un pont me captivaient plus que des contre-plongées spectaculaires.

En somme, la photographie verticale s'est transformée en conception verticale de l'image, avec tout ce que cela comporte en termes de perception et d'expérience. Désormais, je me laisse davantage guider par la composition verticale que par des objets verticaux. De ce point de vue, je confirme que Paris n'est pas une ville verticale. Pourtant, les Parisiens affairés, les longues ombres, les ruelles étroites, les escaliers raides, les tours d'églises pointues et, même les baguettes et les talons aiguilles des Françaises... Tout cela active mes antennes verticales.

Regardez bien autour de vous et vous constaterez que nous vivons tous dans un monde vertical.

Stay Vertical!

PARIS IS NOT VERTICAL
HORST HAMANN

"Paris is not a vertical city!" Or so I have heard, almost as a complaint, time and again during my vertical reconnaissance trips through Paris over the last ten years – and not only from the French.

The Eiffel Tower is tall and catches the eye immediately. But after that, one is at a loss. La Tour Montparnasse and La Défense perhaps, but then that's it. Paris is flat and spread-out – not tall, and certainly not vertical. Now it's up to me. Self-confident and with my own way of seeing things, the perspective I honed over the years in New York (New York Vertical) – stiff neck included. Sensitized to vertical perspectives and equipped with a new panoramic camera (Hasselblad X-Pan) that seems tailor-made for my way of working, I turn my lens to the next challenge: Paris – that seemingly non-vertical city.

The great French metropolis has always held a certain attraction for me. As far back as twenty-five years ago, I would sometimes cut school and buzz over to Paris in the morning in my first car, an old VW Beetle, for a café au lait and a couple of photos. Back in Mannheim in the evening, I would boast of my exploits with a receipt (for the aforementioned café au lait) and a handful of francs, in change, as my proof. For a young man from a provincial city and for recent graduates itching to travel, it was the shortest way out into the wide world. My decision to participate in a study-abroad trip (where I took my first pictures of Paris that can actually be taken seriously) cost me my regular place as a center forward with FV 09 Weinheim. Fritz Walter (the younger one) took over my position afterward. To this day I sometimes ask myself if it was the right decision. Fritz Walter joined VFB Stuttgart and became the German soccer league goal-scoring champion, while from then on my own "shots" were judged on different criteria altogether.

I later met my wife Marie, a Frenchwoman (!), in New York. For three years we kept a small second apartment near the Jardin du Luxembourg. My connection to Paris was never broken (despite the evidently deep misgivings of my French teacher, to whom I owe that extra year of high school).

When I now consider my earlier shots of Paris, some among them have, like classic souvenirs, assumed a firm place in my photographic trophy case. Others, on the other hand, above all the first Paris Verticals, are early attempts, not yet fully developed. A similar thing happened in New York at the beginning.

By now, however, I no longer need a vertical city with vertical architecture in order to take vertical photos. This development was already taking shape in New York (see New York Vertical, photo, page 59, Houston Street, 1993). When, still during my New York experiments, I went to Hong Kong eight years ago to take photographs there, my work seemed to me to be only a pale imitation of the New York cycle. Naturally, Hong Kong is a visually exciting city, but the skyline and capturing the city in photographs seemed to me too similar to the perspectives in New York, and not a trace was left of the initial excitement and joy I had experienced in Manhattan.

In Paris it was a different story. Here, I was challenged to get closer. To really become familiar with the city and its unique characteristics, I had to rethink long-held habits in how I saw things. What I found visually thrilling was not the search for the top, the vanishing points in the sky, but the inconspicuous, the details at eye level. A crack in a wall or the curved arch of a bridge drew me more than spectacular worm's-eye views.

In short: my vertical photography was transformed into a kind of vertical view of taking photos, with the entire spectrum of perception and experience that goes along with it. I am now guided to a much greater extent by vertical composition than by vertical objects. Seen in this way, I can confirm what others have told me all along: Paris is not a vertical city. The bustling people, however, the long shadows, the narrow alleyways, the slender statues, the steep stairways, the pointed towers of churches, and yes, even the baguettes and the high heels of French women – all of them raise an alarm on my vertical radar screen.

If you pay attention, you can see that the world we live in is indeed vertical in many different ways.

Stay Vertical!

PARIS IST NICHT VERTIKAL
HORST HAMANN

„Paris ist keine vertikale Stadt!" So lautet die Aussage, die ich – fast schon als Beschwerde – im Lauf der letzten zehn Jahre während meiner vertikalen Erkundungen in Paris immer wieder zu hören bekommen habe. Nicht nur von Franzosen.

Der Eiffelturm ist hoch und optisch überragend. Aber dann fällt dem Beobachter schon nicht mehr viel ein. La Tour Montparnasse und La Defense vielleicht noch, aber das wars dann. Paris ist flach und weitläufig – nicht hoch und schon gar nicht vertikal. Doch jetzt bin ich am Zug, selbstbewusst und mit meiner eigenen Sichtweise, meinem über Jahre in New York (New York Vertical) geschulten Blick – steifes Genick inklusive. Sensibilisiert für die vertikale Perspektive und ausgerüstet mit einer neuen Panoramakamera (Hasselblad X-Pan), die für meine Arbeitsweise wie geschaffen scheint, wurde Paris – die augenscheinlich nicht vertikale Stadt – zur nächsten Herausforderung.

Die französische Metropole hat mich schon immer angezogen. Bereits vor 25 Jahren habe ich ab und zu die Schule geschwänzt, um mit meinem ersten Auto, einem alten VW Käfer, auf einen Café au lait und ein paar Photos morgens nach Paris zu brummen und abends in Mannheim mit den Beweisen in Form einer Quittung (für besagten Café) und einer Hand voll Francs an Wechselgeld zu prahlen. Für einen Jungen aus der Provinzstadt und vom Fernweh geplagten Abiturienten war das der kürzeste Weg in die große weite Welt. Die Entscheidung zur Teilnahme an einer Studienfahrt (auf der dann meine ersten ernst zu nehmenden Parisbilder entstanden), kostete mich meinen Stammplatz als Mittelstürmer beim FV 09 Weinheim. Den Posten übernahm danach Fritz Walter (der Jüngere). Bis heute frage ich mich manchmal, ob diese Entscheidung richtig war. Fritz Walter wurde Bundesliga-Torschützenkönig beim VFB Stuttgart, meine „Schussstärke" wurde fortan mit anderen Maßstäben gemessen.

Später habe ich in New York meine Frau Marie kennen gelernt, eine Französin (!). Drei Jahre lang hatten wir eine kleine Zweitwohnung am Jardin du Luxembourg. Die Verbindung zu Paris ist also nie abgebrochen (trotz größter Zweifel meiner Französischlehrerin, der ich eine Ehrenrunde auf dem Gymnasium zu verdanken habe).

Wenn ich mir meine früheren Paris-Aufnahmen betrachte, dann gibt es darunter einige, die wie klassische Erinnerungsstücke einen festen Platz in meinem photographischen Trophäenschrank einnehmen. Andere dagegen, vor allem die ersten Paris Verticals, sind eher unausgereifte Versuche. Das ist mir in New York am Anfang ähnlich ergangen.

Doch mittlerweile benötige ich keine vertikale Stadt oder Architektur mehr, um vertikale Photos zu machen. Diese Entwicklung hat sich schon in New York angebahnt (s. New York Vertical, Abb. Seite 59, Houston Street, 1993). Als ich vor acht Jahren, noch während meiner New York-Experimente, in Hongkong photographierte, kam mir die Arbeit wie ein lauwarmer Abklatsch des New York-Zyklus vor. Natürlich ist Hongkong eine visuell aufregende Stadt, jedoch die Skyline und die photographische Umsetzung ähnelte mir zu sehr den Perspektiven von New York, und von der ersten Aufregung und Lust, die ich in Manhattan empfunden hatte, war nichts zu spüren.

Ganz anders in Paris. Hier war ich gefordert näher heranzurücken. Um der Stadt mit ihren eigenen Charakteristiken gerecht zu werden, musste ich erlernte Sehgewohnheiten überdenken. Nicht die Suche nach dem Oben, den Fluchtpunkten am Himmel, sondern vielmehr die Details auf Augenhöhe, das Unscheinbare, empfand ich als visuell spannend. Ein Riss in der Wand oder ein geschwungener Brückenbogen zogen mich mehr an als spektakuläre Froschperspektiven.

Kurzum: Aus der vertikalen Photographie wurde eine vertikale Bildauffassung mit dem ganzen, dazugehörigen Spektrum an Wahrnehmung und Erfahrung. Heute lasse ich mich sehr viel stärker von der vertikalen Komposition als durch das vertikale Objekt leiten. So gesehen kann ich bestätigen: Paris ist keine vertikale Stadt. Die geschäftigen Menschen jedoch, die langen Schatten, die engen Gassen, die schlanken Statuen, die steilen Treppenaufgänge, die spitzen Kirchtürme, ja selbst die Baguettes und die High Heels der französischen Frauen, sie alle schlagen auf meinem vertikalen Radarschirm Alarm.

Achten Sie einmal darauf und Sie werden feststellen, dass wir in einer vertikalen Welt leben, wenn wir sie etwas genauer betrachten.

Stay Vertical!

PARÍS NO ES VERTICAL
HORST HAMANN

«¡París no es ninguna ciudad vertical!» Esta declaración, casi una queja, la suelo escuchar una y otra vez en el curso de los últimos diez años durante mis exploraciones verticales. No sólo de franceses. Bueno, la Torre Eiffel es alta y resalta también desde el punto de vista óptico.

Luego, ya no se le ocurre mucho al observador. Tal vez, recordará la Tour Montparnasse y La Defense... y nada más. París es plana y extensa, pero no es alta... y de ningún modo vertical. Pero ahora me toca a mí. Estoy seguro de mí mismo, tengo mi punto de vista propio, mi visión formada con los años en Nueva York (New York Vertical), incluyendo una nuca rígida. Estoy sensibilizado en cuanto a la perspectiva vertical y equipado con una nueva cámara panorámica (Hasselblad X-Pan), ideal para mi modo de trabajar, me dediqué al próximo desafío de París, una ciudad – como dicen – no vertical.

La metrópoli francesa siempre me había atraído. Ya hace 25 años me había fumado las clases para viajar por la madrugada en mi primer coche, un escarabajo viejo, a París, para tomar un café con leche y sacar algunas fotos. Por la noche volvía a Mannheim, presentando pruebas en forma de un recibo (del café) y un par de francos de cambio para impresionar a mis amigos. Para un joven de una ciudad de provincias que padecía de nostalgia de países lejanos, éste fue el camino más corto al ancho mundo. La decisión de participar en un viaje de estudios (en el que sacaba mis primeras fotos serias de París) me costó mi puesto como centro en el equipo de fútbol del FV 09 Weinheim. Mi lugar fue ocupado por Fritz Walter (el joven). Incluso hoy en día me pregunto si había tomado una decisión acertada. Fritz Walter llegó a ser el máximo goleador de la Bundesliga con el equipo del VFB Stuttgart, mientras que yo me veía obligado a demostrar mi talento en otros ámbitos.

Más tarde, en Nueva York, conocía a Marie, ¡una francesa!, con la que iba a casarme. Durante tres años teníamos un segundo domicilio de dos habitaciones en el Jardin du Luxembourg. Efectivamente, jamás he cortado mis lazos con París (a pesar de que mi profesora de francés, que me había costado un año en el colegio, tenía serias dudas al respecto).

Al mirar mis primeras fotos de París, encuentro algunas que ocupan – como recuerdos clásicos – un lugar fijo entre mis trofeos fotográficos. Otras, por el contrario, como las primeras ‹Paris Verticals›, no son más que ensayos poco maduros. Al principio, fue similar en Nueva York.

Mientras tanto, ya no necesito ninguna ciudad o arquitectura para sacar fotos verticales. Este desarrollo ya se iba vaticinando en Nueva York (véase New York Vertical, foto en la pág. 59, Houston Street, 1993). Cuando hace ocho años, aún durante mis experimentos en Nueva York, fotografiaba en Hong Kong, este trabajo me parecía ser una mala copia de mi ciclo de Nueva York. Es cierto que Hong Kong es una ciudad emocionante desde el punto de vista óptico, sin embargo su horizonte y la captación fotográfica se parecían demasiado a las perspectivas de Nueva York y ya no sentía la emoción y la pasión de mis primeras fotos en Manhattan.

París era muy diferente. Aquí debía acercarme mucho más. Para descubrir a la ciudad y sus características, tenía que reformar mis costumbres visuales. Ya no se trataba de buscar a gran altura, en los puntos de fuga en el cielo. La emoción visual nacía ahora de los detalles a la altura de los ojos y de lo a primera vista poco atractivo. Una fisura en la pared o el arco elegante de un puente me fascinaban más que alguna vista espectacular desde abajo.

Dicho con otras palabras: La fotografía vertical se convirtió en captación vertical de imágenes con el espectro correspondiente de percepción y experiencia. Hoy me hago guiar mucho más por la composición vertical que por el objeto vertical. Desde este punto de vista puedo afirmar: París no es ninguna ciudad vertical. Sin embargo, sus habitantes diligentes, las sombras largas, los callejones estrechos, las estatuas esbeltas y elegantes, las escaleras escarpadas, las torres puntiagudas de sus iglesias e incluso las típicas barras de pan y los tacones de las mujeres francesas tocan la alarma en mi pantalla de radar vertical.

Preste atención a ello y podrá comprobar, si lo observa con más detalle, que vivimos en un mundo vertical.

Stay Vertical!

PARIGI NON È VERTICALE
HORST HAMANN

«Parigi non è una città verticale!» Ecco l'asserzione che mi sono sentito ripetere continuamente – spesso quasi con un tono di rimprovero – per dieci anni, durante le mie esplorazioni su Parigi come città verticale. E non erano solo i Francesi a rispondermi così.

La torre Eiffel è alta e l'effetto ottico è imponente, certo. Ma oltre ad essa il visitatore non trova molti altri esempi. Forse ancora la Tour Montparnasse e La Défense, ma questo è tutto. Parigi si estende in superficie, ma non è alta, e certamente non verticale. E quindi ho dovuto darmi da fare, con la consapevolezza del mio lavoro e la visione personale che mi sono fatto esercitando il mio sguardo per anni attraverso New York (New York Vertical), anche a spese di numerosi torcicolli. Sensibile alla prospettiva verticale e munito di una nuova macchina fotografica panoramica (Hasselblad X-Pan), che sembra fatta apposta per il mio lavoro, ho affrontato Parigi, la città non verticale, come nuova sfida.

La metropoli francese mi ha sempre attirato. Già 25 anni fa mi capitava di marinare la scuola e mettermi in moto la mattina a bordo della mia prima macchina, un maggiolino Volkswagen vecchio e rumoroso, in direzione Parigi per bere un ‹café au lait› e scattare un paio di foto e poi la sera, a Mannheim, ostentare le prove della mia bravata: uno scontrino (del suddetto caffè) e una manciata di franchi. Per un giovane di una città di provincia, un maturando tormentato dal desiderio di viaggiare, quella era la strada più breve per entrare nel grande mondo che sembrava così lontano. La scelta di partecipare ad un viaggio studio a Parigi (al quale risalgono le mie prime foto di Parigi degne di questo nome) mi costò il posto di centravanti nel FV 09 Weinheim. Fu Fritz Walter (junior) a prendere quel posto. Ancora oggi mi chiedo a volte se la mia sia stata la scelta giusta. Fritz Walter divenne capocannoniere della Bundesliga nel VFB Stuttgart. I miei exploit invece si cominciò a misurarli secondo altri criteri.

Più tardi a New York conobbi mia moglie Marie, francese (!). Abitammo per tre anni in un appartamento di due locali nei pressi del Giardino del Lussemburgo. Il mio legame con Parigi quindi non si è mai spezzato, nonostante i grossi dubbi della mia insegnante di francese (che mi onorò anche di una bocciatura al liceo).

Quando osservo le mie prime inquadrature su Parigi, ne trovo alcune a cui spetta un posto d'onore (come classici souvenir) nel mio armadio dei trofei. Altre, invece, e soprattutto le prime su ‹Parigi verticale›, sono tentativi ancora acerbi. Anche a New York all'inizio mi era successa la stessa cosa.

Nel frattempo però non ho più bisogno di una città o di un'architettura verticale per fare foto verticali. Quest'evoluzione l'avevo già notata a New York (cfr. New York Vertical, foto a pag. 59, Houston Street, 1993). Quando otto anni fa – durante i miei esperimenti a New York – feci delle foto a Hong Kong, venne fuori una copia mal riuscita del ciclo di New York. Hong Kong è certamente una città eccitante, ma i profili e la trasposizione fotografica si avvicinavano molto alle prospettive di New York e nulla più restava della primitiva emozione e del sentimento che avevo provato a Manhattan.

A Parigi è stato ben diverso. Quello che qui mi veniva richiesto era di guardare più da vicino: per tenere conto delle caratteristiche di questa città, dovevo imparare a guardarla diversamente da come avevo fatto fino ad allora. Non era più la ricerca di punti di fuga nel cielo che trovavo appassionante dal punto di vista visivo, bensì soprattutto la ricerca di dettagli all'altezza degli occhi, di ciò che è poco appariscente. Uno strappo alla parete o l'arcata di un ponte mi davano emozioni più forti di prospettive dal basso mozzafiato.

Insomma, dalla fotografia verticale sono passato ad un'interpretazione verticale dell'immagine con tutto lo spettro di percezione e l'esperienza che ne deriva. Oggi mi faccio ispirare più dalla composizione verticale che dall'oggetto verticale. E con questo bagaglio alle spalle posso dire: Parigi non è una città verticale. Eppure la gente indaffarata, le ombre lunghe, le strade strette, le statue slanciate, le scale ripide, i campanili a punta, perfino le baguettes e i tacchi a spillo delle donne francesi: tutti questi elementi sono nel mirino del mio obiettivo verticale.

Fateci attenzione una volta e vi accorgerete che, se lo consideriamo attentamente, viviamo in un mondo verticale.

Stay Vertical!

ZITATE

CITAS

CITAZIONI

HORST HAMANN

EXHIBITIONS

1980 **CARS AND STRIPES** Fotografische Sammlung Bongartz, Krefeld
1984 **BILDER EINER AUSSTELLUNG** Künstlerhaus am Karlsplatz, Vienna
1985 **KÜNSTLERPORTRAITS** Kunsthaus Hamburg, Hamburg
1986 **KONFRONTATIONEN** Ernst Museum, Budapest
1991 **BOTTICELLI MEETS BEUYS** Centre Culturel, Montpellier
1993 **ABSOLUT MANHATTAN** Nikon House, New York
1994 **IMAGES WITHOUT IMAGES** Electronic Nuyorican Poets Cafe, NY – LA – SF
1996 **NEW YORK VERTICAL** New York Vertical Photokina, Cologne
1999 **NEW YORK VERTICAL** Museum of the City of New York, New York
1999 **NEW YORK VERTICAL** Internationale Fototage Herten, Herten
1999 **NEUE WEGE IN DER INDUSTRIEFOTOGRAFIE** Wilhelm-Hack-Museum, Lu./Rh.
2000 **VERTICALS** Vanderbilt Hall, Grand Central Terminal, New York
2001 **VERTICAL VIEW, 1991–2001** Center for Maine Contemporary Arts, Rockport, Maine
2001 **CITY** Brooke Alexander Gallery, New York
2002 **HORST HAMANN: NEW YORK** The Photographer's Gallery, London
2002 **CONTRASTS** National Arts Club, New York
2002 **NEW YORK** Michael Hoppen Gallery, London
2002 **911** Library of Congress, Washington
2003 **VERTICAL VIEW** Galerie Kasten, Art Chicago, Chicago
2003 **DIE NEUE KUNSTHALLE** Kunsthalle Mannheim, Mannheim
2004 **NEW YORK VERTICAL** The Museum of Architecture, Photobiennale Moscow
2004 **NEW YORK VERTICAL** Galerie IHN, Seoul, South Corea

FILM

1995 **THEY DIDN'T KNOW …** Anti-AIDS film, Madison Square Garden, New York
Director of Photography
2001 **910 – 911 NYC** Short film, 8 min., Script and Direction
Director of Photography
2001 **A SMILE GONE, BUT WHERE?** Film after a story by Jimmy Breslin
Director of Photography
2004 **THE OTHER SIDE OF THE STREET** A documentary about Jimmy Breslin
Director of Photography

BIBLIOGRAPHY

1994 **HUGHES, HOLLY STUART** "Horst Hamann loves New York" in: Photo District News, New York 4/94
1996 **HESS, HANS-EBERHARD** "New York Vertical" in: Photo Technik International, Munich, 9/96
1996 **LANGER, FREDDY** "So hoch – Horst Hamann fotografiert New York" in: Frankfurter Allgemeine Zeitung, Frankfurt/Main, 227/96
1996 **LANGEN, ANDREAS** "New York vertikal – die Wolkenkratzer – City im Hochformat" in: Stuttgarter Zeitung, Stuttgart, 50/96
1997 **WILLEMSEN, ROGER** "New York Vertical" in: Vogue, Munich 1/97
1998 **MACNEILLE, SUZANNE** "Head for Heights" in: New York Times, New York 3/98
1999 **GUTTMANN, KATJA** "Horst Hamann / Portfolio" in: Photographie 7–8/99 und 9/99
1999 **ZOLLNER, MANFRED** "Horst Hamann – Paris Vertical" in: Foto Magazin, Munich 11/99
1999 **MUSCHAMP, HERBERT** "Steel Dreams That the Eye Can Cherish" in: New York Times, New York 1/99
2001 **SAEBISCH, BABETTE** "Der Waghalsige unter den Fotografen" in: Der Frankfurter, Frankfurt/Main 3–4/01
2002 **JONCKHEER, LIZ** "One Night on Broadway" in: Photo District News New York 11/02
2003 **GRABER, BERND** "Trainspotting – Made in Germany" in: Mannheimer Morgen, Mannheim 8/03
2003 **MEERS, NICK** "Masters of Panorama Photography" in: Stretch, RotoVision, UK
2004 **PROFOTO RUSSIA** Moscow 14–4/2004
2004 **GODRECHE, DOMINIQUE** 5e Edition Photobiennale, Moscow, Photo France 409 05/04
2004 **5th INTERNATIONAL MONTH OF PHOTOGRAPHY MOSCOW** Catalogue, Moscow House of Photography, 2004

BOOKS

1992 **ABSOLUT MANHATTAN** N.Y. State of Mind Publishing, New York 1992

1996 **NEW YORK VERTICAL** Edition Quadrat, Mannheim 1996

1999 **FACES OF A COMPANY** Edition Panorama, Mannheim 1999

2001 **HORST HAMANN NEW YORK** Edition Panorama, Mannheim 2001

2001 **VERTICAL VIEW** Edition Panorama, Mannheim 2001

2003 **PANORAMA DEUTSCHE BAHN** Edition Panorama, Mannheim 2003

2004 **ONE NIGHT ON BROADWAY** Schirmer / Mosel, Munich 2004

2004 **PARIS VERTICAL** Edition Panorama, Mannheim 2004

TV & RADIO

1995 **SDR 3, SÜDDEUTSCHER RUNDFUNK TV** (Klünder, Irene)
"Portrait: Horst Hamann über New York" in: Landesschau, Stuttgart 1995

1997 **ARD, SÜDDEUTSCHER RUNDFUNK TV** (Krupok, Isolde)
"Horst Hamann in New York" in: Mensch, Leute!, Stuttgart 1997

1997 **ARTE TV** (Pütz, Günter)
"Horst Hamann und seine vertikale Sichtweise" in: Metropolis, Strasbourg 1997

1998 **ZDF ZWEITES DEUTSCHES FERNSEHEN TV** (Hess, Jutta)
"New York im Hochformat – die Fotos von Horst Hamann" in: Aspekte, Mainz 1998

1998 **SWF, SÜDWESTFUNK TV** (Buettner, Tilman)
"Im Schatten der Wall Street" in: USA, Baden-Baden 1998

1998 **WNBC TV** (Taylor, Felicia)
"Horst Hamann at the Museum of the City of New York"
in: Sunday Today in New York, New York 1998

1999 **RNF TV** (Siegelmann, Bert)
"Studiogast Horst Hamann" in: Profil, Mannheim 1999

1999 **SWR, SÜDWESTRUNDFUNK TV** (Kilwink, Isa)
"Der Senkrechtstarter" in: Nahaufnahme, SWR, Mainz 1999

1999 **BBC TV** (Potter, Elisabeth)
"New York Vertical at the Museum of the City of New York"
in: BBC News, New York – London 1999

1999 **PBS TV** (Deroy, Jaimee)
"Vertical Photographs at the Museum of the City of New York"
in: City Arts, New York 1999

1999 **ARTE TV** (Burchardt, Melanie)
"Big Apple bei den Fototagen in Herten", in: Tracks Strasbourg 1999

1999 **SWR 3 SÜDWESTRUNDFUNK RADIO** (Ries, Michael)
"Studiogast Horst Hamann" in: Leute, Stuttgart 1999

1999 **SWR SÜDWESTRUNDFUNK TV** (Hattensen, Maja)
"Neue Wege in der Industriefotografie" in: Kulturreport, Mainz 1999

1999 **HR 3, HESSISCHER RUNDFUNK TV** (Soliman, Tina)
"Mr. Vertical" in: Moderne Menschen, Frankfurt/Main 1999

2002 **BBC SCOTLAND** (Morton, Brian)
"Live Gäste incl. Norman Mailer, Horst Hamann" in: BBC
Edinburgh/New York 1/02

2003 **SWR SÜDWESTRUNDFUNK TV**
"Studiogast Horst Hamann" in: Kultur Cafe, Baden-Baden 2003

COLLECTIONS

AGFA GEVAERT COLLECTION, Leverkusen

FOTOGRAFISCHE SAMMLUNG BONGARTZ, Krefeld

MUSEUM OF THE CITY OF NEW YORK, New York

SAATCHI COLLECTION, London

PORTLAND MUSEUM OF ART, Portland

GOLDMAN SACHS COLLECTION, New York

MOSCOW HOUSE OF PHOTOGRAPHY, Moscow

HORST HAMANN

Horst Hamann travaille sur la photographie panoramique depuis vingt ans. Il jouit d'une renommée internationale et ses photographies de New York, objets de nombreuses expositions, ont été réunies dans un ouvrage intitulé ‹New York Vertical› et plus récemment dans ‹One Night on Broadway›. Ses livres sont deux grands succès de librairie.

Horst Hamann has focused on panoramic photography for the last twenty years. His internationally acclaimed and widely exhibited photographs of New York have been published in the best-selling books "New York Vertical" and, more recently, in "One Night on Broadway".

Horst Hamann photographiert seit mehr als zwanzig Jahren im Panoramaformat. Seine Arbeiten werden weltweit ausgestellt und befinden sich in öffentlichen und privaten Sammlungen. Zu den international bekanntesten Veröffentlichungen gehören der Bestseller „New York Vertical" sowie „One Night on Broadway".

Horst Hamann se dedica desde hace veinte años a la fotografía panorámica. Sus fotografías de Nueva York, galardonadas internacionalmente y exhibidas en todo el mundo, han sido publicadas en los libros best seller ‹New York Vertical› y, más recientemente, ‹One Night On Broadway›.

Negli ultimi vent'anni Horst Hamann si è dedicato alla fotografia panoramica. Le sue foto di New York, largamente apprezzate ed esposte a livello internazionale, sono state pubblicate all'interno del libro ‹New York Vertical›, uno dei maggiori best-seller e, di recente, in ‹One Night on Broadway›.

MERCI MARIE, MATÉO & PAOLO

REMERCIEMENTS

Maria Hamann, Dominique Préaud, Andreas Bee, Bernhard Wipfler, Wolle Roth, Sonja & Angelo Lomeo, Heinrich Gröger, Johannes & Doreen & Jillian Hamann, Leo Strohm, Cornelia Franz, Lutz Bernstein, Stephanie & Matthias Hamann, Michael Gregoire, Sebastian & Benjamin Wipfler, Werner Bochmann, Hendrik te Neues, Philip Vormwald, Martin Page, Carsten Wolff, Anita Beckers, Babette Grospiron, Caterine Milinaire, Cecile zu Hohenlohe, Cyril de Commarque, Ilona & Friedemann Leinert, Andrea & Friedrich Kasten, Hansjoachim Nierentz, Isa Kilwink, J. J. Straub, Jochen Rohner, Jutta Hess, Kevin Breslin, Ludwig Linden, Marcus Schwetasch, Margaret Donovan, Michael Gray, Ann & Robert Brochu, Roger Conover, Sarah Tittle, Serafine Klarwein-Milinaire, Tilman Buettner, Udo van Kampen, Veronique Nguyen, Werner Schwarzer, Irene & Wulf Liebau, Alice, Eric Schloss, Peter Voss, Marine & Philippe Royer-Kerjan, Tifenn de la Combe, Luc Daniel, Carolyn Lougee Chappelle, Yvonne & Michael Behnke, Tilo Kaiser, Peter Lindbergh, Aurélie Ben Barek, Jaques Riboux, Katia Kulawick, Olivier Gossart, Gerhard Vormwald, Olga Sviblova, Marie le Fort, Gérard Benoît à la Guillaume, Eric Baronne, Christiane Bop, Pierre Doris, Alain Schifres, Philippe Muyl, Art Buchwald, Somerset Maugham, Zoé Valdès, Paul Claudel, Pierre Grognet, Maxime Préaud, Georges Courteline, Humphrey Davy, Kenneth Stilling, Paul Pagk, Jean Nouvel, Marcel Carné, Hyun Soo, Daniel Grand-Clément, Jean-Marie Monthiers, Gerd Laubmann, Christian Riedlinger, Winfried Rothermel, Werner Rehberger, Norbert Terbeck, Ralf Niehues, Marcus Plazz, Irmgard Kuhn-Geiselhart, Christel Ferino, Gerd & Linde Schwetasch, Dominique Eckstein, Sophie Monbeig, Richard Schleuning (Hasselblad USA)

IMPRINT

First Edition 2005
© 2005 EDITION PANORAMA, Germany & Horst Hamann

Published by EDITION PANORAMA, Germany
Published internationally by teNeues Publishing Group:
Kempen, Düsseldorf, London, Madrid, New York, Paris
© all photographs by Horst Hamann
Camera: Hasselblad Xpan
© 2004 essay by Martin Page
© 2004 Realisation: Limited Eyedition Inc.:
Marie Préaud, Dominique Préaud, Cornelia Franz, Leo Strohm
Translations: Kern Corporation, New York
Art Direction: Horst Hamann
Design: Michael Gregoire
Typographical Support: Carsten Wolff, Thomas Rott
Seperations: Werner Bochmann
CTP: Satin Screen FM Raster, 2nd Generation
Printing: abcdruck GmbH, Heidelberg
Printed on Heidelberg Speedmaster
Printed on Profisik
Binding: Großbuchbinderei Spinner
ISBN: 3-8327-9030-6 (international edition)

© Quotations by the authors: Tilo Kaiser, Le Corbusier, Elliot Paul, Hyun Soo Choi, Véronique Nguyen, Jules Renard, Gustave Eiffel, Napoléon Bonaparte, Erik Satie, Prince Metternich, Paul Cézanne, Alfred de Vigny, Steve Martin, Paul Guth, Peter Lindbergh, Aurélie Ben Barek, Jaques Riboux, Honoré de Balzac, Alexandre Dumas, Katia Kulawick, Cole Porter, Robert Garnier, Daniel Grand-Clément, Kenneth Stilling, Charles Pìnot Duclos, Josephine Baker, Gilbert Bécaud, Olivier Gossart, Friedrich Wilhelm Nietzsche, Charles Baudelaire, Jean-Marie Monthiers, Victor Hugo, Jean-Jacques Rousseau, Allen Ginsberg, Gerhard Vormwald, Olga Sviblova, Ernest Hemingway, Marie le Fort, Edith Piaf, Gérard Benoît à la Guillaume, Eric Baronne, Christiane Bop, Pierre Doris, Alain Schifres, Philippe Muyl, Art Buchwald, Guillaume Apollinaìre, Jean Cocteau, Somerset Maugham, Zoé Valdès, Paul Claudel, Pierre Grognet, Maxime Préaud, Dominique Barra, Georges Courteline, Humphrey Davy, Eric Dupont, Paul Pagk, Jim Morrison, Jean Nouvel, Ernst Haas, John Fitzgerald Kennedy, Marcel Carné, Gertrude Stein

www.horsthamann.com
www.editionpanorama.de
www.teneues.com

A production by EDITION**PANORAMA** , Germany
Publisher: Bernhard Wipfler